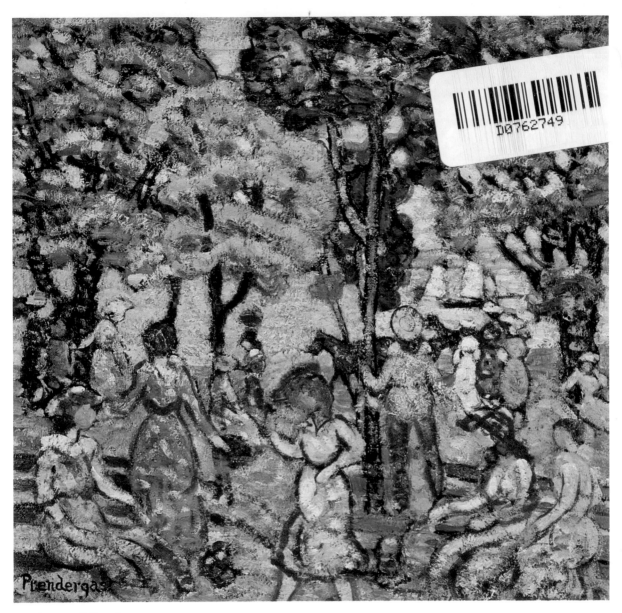

Maurice Brazil Prendergast
Summer Day in the Park (figure 44)

Charles Prendergast
Golden Fantasy (figure 28)

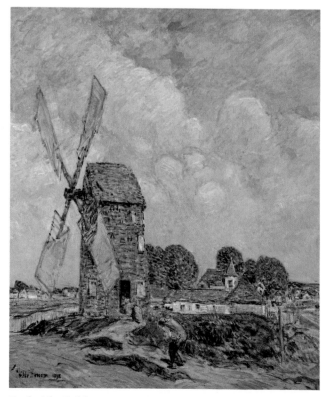

Frederick Childe Hassam
Old Hook Mill, Easthampton (figure 12)

AMERICAN IMPRESSIONIST AND REALIST PAINTINGS AND DRAWINGS FROM THE WILLIAM MARSHALL FULLER COLLECTION

Amon Carter Museum of Western Art
Fort Worth, Texas
May 25 - July 16, 1978

by
Carol Clark
Curator of Paintings
Amon Carter Museum

The Amon Carter Museum was established in 1961 under the
will of the late Amon G. Carter for the study and
documentation of westering North America. The program of
the museum, expressed in publications, exhibitions, and
permanent collections, reflects many aspects of American
culture, both historic and contemporary.

Photography by Linda Lorenz

The museum has been generously assisted in the publication
of this catalogue by The Fuller Foundation.

Library of Congress Catalog Card Number 78-54779.
ISBN 0-88360-029-3.
Lithographed in U.S.A.

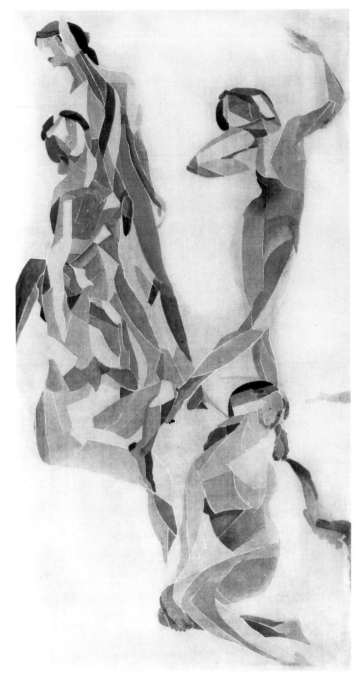

1. Arthur B. Davies (1862-1928), *Eye Beams*. 1913. Pencil, watercolor, and gouache on silk, 22 x 11 in. (55.9 x 27.9). Provenance: Estate of the artist, James Graham & Sons Galleries, New York, Mr. and Mrs. William M. Fuller, Adelaide Fuller Biggs.

INTRODUCTION

In 1952 Mr. and Mrs. William M. Fuller purchased two watercolors by Maurice Prendergast, *The Flying Swings*, and *Paris Boulevard in the Rain*. Although they intended to acquire only one at that time, they could not face the prospect of returning the other to the dealer so decided to keep both. This was the beginning of an interest in early modern American art, generated by a close friend and Fort Worth collector, the late Sam Cantey III, and supported by dealers in New York who shared their enthusiasm. Throughout twenty-five years of friendship Miss Antoinette Kraushaar, from whom the Fullers acquired *The Flying Swings*, has brought important and beautiful works to their attention, continuing the tradition of the Kraushaar Galleries in support of Maurice Prendergast, his brother Charles, and members of the group of artists known as "The Eight."

During the 1950s the Fullers continued to purchase Prendergast watercolors, but determined to own at least one work by each member of "The Eight." They were aided in this quest by the expertise of William F. Davidson of M. Knoedler & Co., James Graham, Stewart Lacy of Milch Gallery, and Norman Hirschl. Gradually, paintings in oil by Maurice Prendergast, Childe Hassam, and John Twachtman entered their collection. Yet Mrs. Fuller, in particular, always has been attracted to the luminosity of watercolors and the delicacy and intimacy of drawings, formative works in the collection. Charles Prendergast, an artist whose works are primarily in private hands, holds a special place in the Fuller collection. Mr. and Mrs. Fuller met Eugénie Prendergast, the artist's widow, during their early years of collecting. Since then, Mrs. Prendergast has shared with the Fullers her personal observations on the works of Charles and Maurice Prendergast.

Throughout the years Mr. and Mrs. Fuller have given paintings and drawings to their daughters, Adelaide Fuller Biggs and Marcia Fuller French, in order to encourage their interest in acquiring works of art. The Fullers rarely have sold or exchanged objects, and then only if a better example in the area of their collection became available. American pictures continue to rise in price, yet the Fullers' strong desire to collect enables them to discover new works and enrich their collection. Maurice Prendergast's *Boy with Red Cap* is the most recent addition to this fine group of American Impressionist and Realist paintings. The Amon Carter Museum is especially pleased to have had the cooperation and interest of the Fullers in bringing about the exhibition of their collection.

5

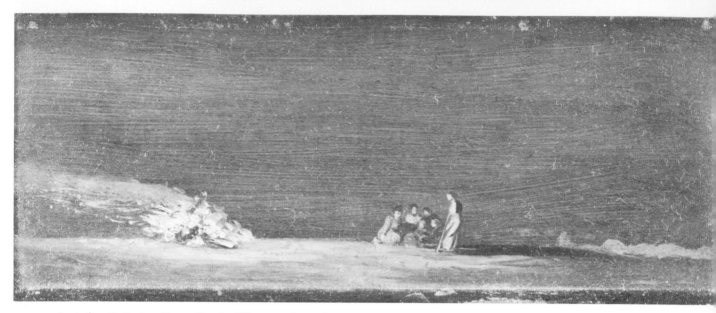

2. Arthur B. Davies, *Fire on Beach*. Oil on wood panel, 4 x 10 in. (10.2 x 25.4). Inscription (verso): "Arthur B. Davies." Provenance: Estate of Lillie P. Bliss, New York, M. Knoedler & Co., Inc., New York, Mr. and Mrs. William M. Fuller.

AMERICAN IMPRESSIONIST AND REALIST PAINTINGS AND DRAWINGS FROM THE WILLIAM MARSHALL FULLER COLLECTION

Conceptually, the William Marshall Fuller collection is bounded by a series of artistic "revolts." The Society of American Artists was formed in 1877; artists known as "The Ten" began to exhibit as a group in 1898; those who came to be called "The Eight" banded together in 1908 for a seminal independent exhibition at William Macbeth's gallery; and 1913 saw the accomplishment of the International Exhibition of Modern Art (the Armory Show). The freedom to exhibit without juries or prizes, primary in artists' hopes since the 1870s, was realized by 1913. Yet that achievement had been at the expense of an attitude of camaraderie and solidarity among artists. A break between identifiably European and American art came clearly to the forefront during the organization of the Armory Show, forcing many artists to defend the virtues of native American art. The revolutions that were taking place during these years were dually based upon a reevaluation of contemporary subject matter and experiments with new styles, chiefly those

developed in France between 1860 and 1890. It may be only natural that defenders of the importance of subject matter would conflict with those to whom style mattered most.

Knowledge of any period comes, however, through specific examination of works created during that time as well as from a framework of plans for organizations and exhibitions. It is just such an opportunity that is presented by the Fuller collection. For here we can see major artists of turn-of-the-century America confronting new themes and attempting new styles, against a background of the cities and towns that helped to shape their images: Paris, St. Malo, Boston, Philadelphia, New York, Gloucester, and Greenwich. Each of the artists represented in the collection, with the exception of Theodore Robinson and Charles Prendergast, "belonged" to one of the loose organizations known as "The Ten" or "The Eight." Several were active in the plans for the Armory Show, and many had works of art in that exhibition. All contributed through their

work and their presence to the artistic spirit that brought America into the twentieth century.

During the 1880s American artists first began to look at "modern" art in Europe. Until this time European travel and study had been popular and recommended to artists, who usually left these shores to study in conservative academies, such as those at Düsseldorf and Munich, or to wander in Italy while absorbing the aura of the antique. James Abbott McNeill Whistler left for London and Paris in 1855; Mary Cassatt settled in Paris in 1866; and John Singer Sargent's career in London and Paris began in 1874. Although these artists exhibited in this country and visited America from time to time, they are more generally regarded as expatriates whose lives and art were dependent more on the stimulus of Europe than America. Nevertheless, Whistler, Cassatt, and Sargent were instrumental in forging the acceptance of Impressionism in America. It may be that in the eyes of most Americans the style was closely associated with Barbizon painting, previously popular among collectors and thus more sought after in this country

than in either France or England during the 1880s. Mary Cassatt, especially through her influence on a girlhood friend, Louisine Elder Havemeyer, was largely responsible for interest in collecting French Impressionist pictures in America. In 1883 two exhibitions of paintings by French Impressionist artists were held, one in Boston, and the other in New York (organized to raise funds to build a pedestal for the recent gift of the French government, the Statue of Liberty). Three years later the American Art Association sponsored an exhibition of French Impressionism arranged by the prestigious dealer Paul Durand-Ruel. The show was so successful that Durand-Ruel opened a permanent gallery in New York in 1888.

Surprisingly few of the collectors of French Impressionism showed even a slight interest in American practitioners of that style. The pattern of collecting and support for artists in America continued much as it had since the end of the Civil War, with vast sums spent on Renaissance and Baroque works, increasing amounts on

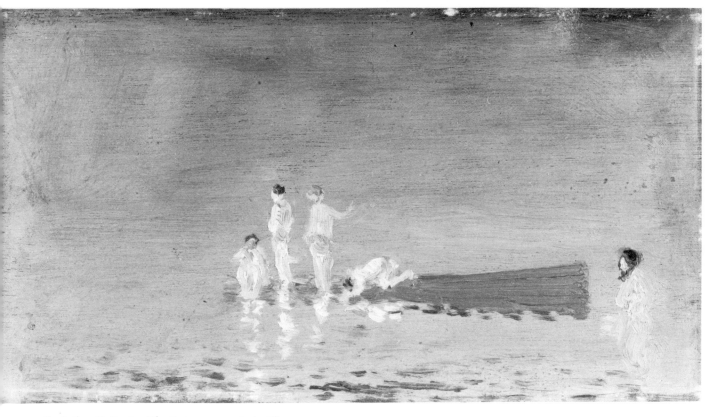

3. Arthur B. Davies, *The Swimmers* or *Late Afternoon*. Oil on wood panel, 5-1/8 x 9-3/8 in. (13.0 x 23.8). Provenance: Estate of the artist, Ferargil Galleries, New York, Davis Galleries, New York, Mr. and Mrs. William M. Fuller.

contemporary French and English artists, and almost nothing on American artists. Only as the century drew to a close did a few farsighted collectors, notably John Gellatly, William T. Evans, and Charles Lang Freer, begin to collect contemporary American paintings.

Artists who were closest to the style of Claude Monet gained the greatest recognition among the American public. Monet's work was quite well known in this country through the group exhibitions in Boston and New York and the individual shows of his paintings organized in New York in the early 1890s. Following the accomplishments of the 1870s, Monet's work took new directions, and the artist physically removed himself from Paris to the village of Giverny. From 1883 until his death in 1926 Monet lived at Giverny, depicting the dissolution of light through the series of canvases of nearby Rouen Cathedral, haystacks of the region, and his own garden. It was here that a number of American artists came to be near the French artist, remaining as neighbors and fellow painters. In 1887 Theodore Robinson arrived in Giverny following sound academic training in New York and Paris. For the better part of the next five years Robinson painted with Monet, coming to understand the French artist's obsession with light, while maintaining the firm draughtsmanship and solidity of form that gave special character to his painting. With the exception of Mary Cassatt, who exhibited with the French Impressionists, no American artist came as close as Robinson to an understanding of the tenets of the style.

With less than four years to live, Robinson returned to America, determined to bring the lessons and the sensibility he had gained through his close association with Monet to the painting of American scenes. His friendship with John H. Twachtman drew him to the towns north of New York City — Cos Cob, Riverside, and Greenwich, Connecticut — where Twachtman welcomed artists to his farm to explore the countryside and enjoy the pleasures of shared discussions about their work. Robinson spent only one summer, 1894, at Cos Cob, attracted by the light and color of the picturesque fishing village. Here he succeeded in uniting his understanding of painting the dissolution of light with an American subject. Many of his finest canvases were painted during that summer, among them *The Anchorage, Cos Cob, Connecticut* (figure 50). Identification of time and place were important components of Robinson's work during this period. His journal records observations of atmospheric changes and attention to variations of light reflections as the sun changed position during the day. This attachment to subject and strength of composition through firm

linear control of form are two qualities that distinguish Robinson's work and American Impressionism from its French counterpart.

Another distinguishing characteristic is a certain subjectivity of approach to painting, different from the more scientific French interest in light reflection. Of all the American Impressionists, John Twachtman's work best expresses this subjective attitude. Like Robinson, Twachtman spent time in France as a student at the Académie Julian. Yet he was not drawn to the circle of Monet as was Robinson. He spent the summers of his French stay of 1883-1885 along the Normandy coast, traveling as far as Dieppe. Rather than busy fishing villages and resorts, Twachtman painted the quiet spots of the Channel coast well suited to his palette of low-keyed colors and limited tonal variations.

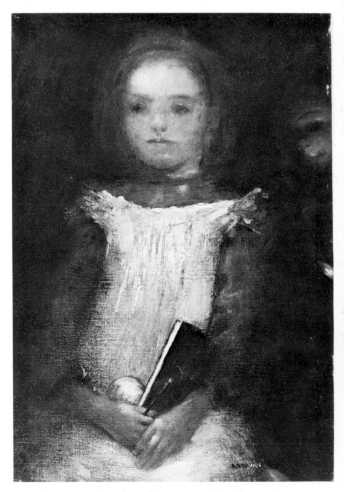

4. Arthur B. Davies, *The Whisperer*. 1890s. Oil on canvas, 16 x 11 in. (40.6 x 27.9). Inscription (lower right): "A. B. Davies." Provenance: Sotheby Parke Bernet, Inc., New York, Kraushaar Galleries, New York, Mr. and Mrs. William M. Fuller.

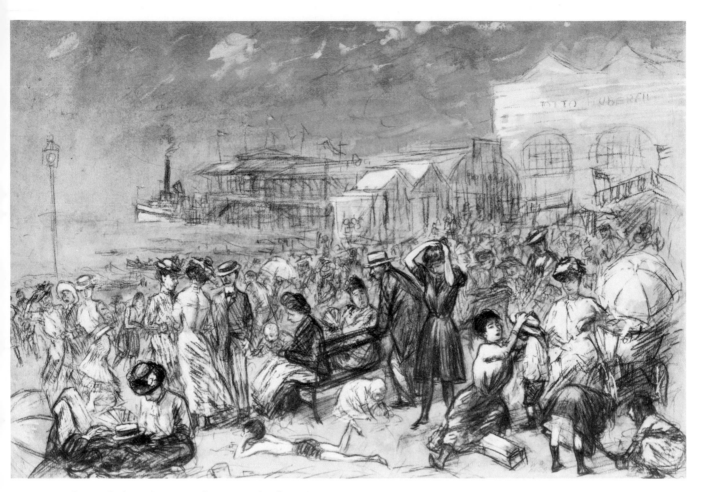

5. William Glackens (1870-1938), *Coney Island*. 1902.
Charcoal and gouache on paper, 14 x 21-1/4 in. (35.5 x
54.0). Inscription (lower right): "W. G./per I. G." Verso:
Untitled [figural drawing], charcoal. Provenance: Mr.
Ira Glackens, Kraushaar Galleries, New York, Mr. and
Mrs. William M. Fuller, Marcia Fuller French.

Twachtman had returned to a successful career of
teaching and exhibiting in New York by 1888, but
soon abandoned city life for a farm in Greenwich. It
was a perfect place of solitude for the artist and his
friends, and until his death in 1902 Twachtman
found most of his subjects close to the farm. It
was here that Robinson introduced his host to the
techniques of Impressionism acquired in France,
bringing new and brighter colors to Twachtman's
palette. Twachtman was not nearly as methodical as
Robinson, who used photographs to fix an image in
his mind. He would, instead, seem to dream before a
subject, seeking a reverie and universality of feeling
in the painting of landscape. Comparison of
Robinson's *The Anchorage, Cos Cob, Connecticut* of
1894 (figure 50) and Twachtman's *Sailing* (figure 59)
of two years earlier reveals two poles within the

Impressionist mode. Where Monet had been the
strongest force in the development of Robinson's
style, Whistler exerted a similarly strong influence on
Twachtman's poetic landscapes of mood.

During the 1890s Twachtman took trips beyond his
regular haunts on commission by two Buffalo, New
York, collectors. From these trips came two unusual
series of pictures, one of Niagara Falls, the other of
Yellowstone National Park. The latter was
commissioned by Major W. A. Wadsworth and
engaged Twachtman in scenery that must have
seemed overwhelming to an artist more attuned to
the quiet pond and gently flowing stream. Two
canvases from this series are in the Fuller collection:
Geyser Pool, Yellowstone (figure 57) and *Lower Falls,
Yellowstone* (figure 58). While in the former
Twachtman found a more intimate view similar to

the Hemlock Pool series of his Connecticut farm, the Falls provided an opportunity for a grander sense of scale. The viewer is swept back past colors unusual on Twachtman's palette to an illusionistic depth rarely attempted in the artist's work. It may be that the Lower Falls of Yellowstone would not have been chosen by the artist but for the commission, yet he rose to the opportunity and has left some of the most personal interpretations of that natural wonder so attractive to nineteenth-century artists.

It is not easy to identify strictly those artists whom we now call American Impressionists. Dependence on the French developments of the 1870s and 1880s leaves the definition open to broad interpretation. Yet Winslow Homer, whose own style was established before any contact with the French, is often labeled a "native Impressionist." Indeed a mode of painting in which the depiction of light and its spiritual or secular meaning is prominent had long been accepted as a uniquely American way of viewing the

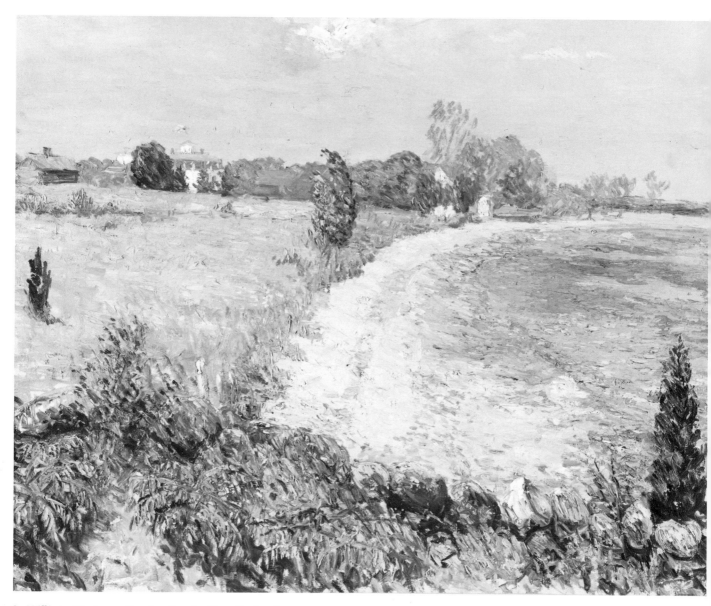

6. William Glackens, *Curving Beach, New England*. Oil on canvas, 26 x 32 in. (66.0 x 81.3). Provenance: Mr. Ira Glackens, Kraushaar Galleries, New York, The Fuller Foundation.

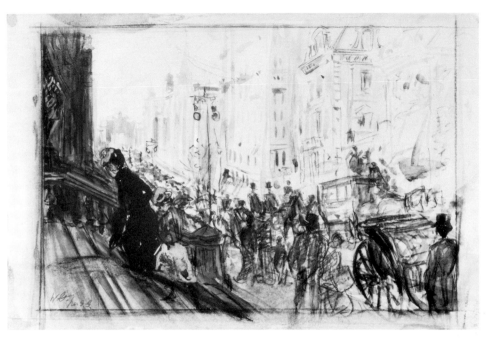

7. William Glackens, *New York*. Watercolor and gouache on paper, 7-1/4 x 10-1/2 in. (18.4 x 26.7). Inscription (lower left): "W. G./per I. G." Provenance: Mr. Ira Glackens, Kraushaar Galleries, New York, Mr. and Mrs. William M. Fuller, Marcia Fuller French.

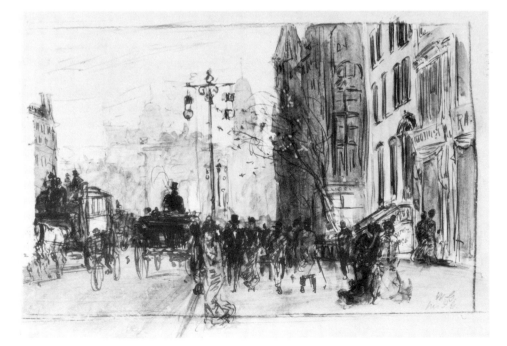

8. William Glackens, *New York*. (Previously verso of figure 7). Pencil, watercolor, and gouache on paper, 7-1/4 x 9-3/4 in. (18.4 x 24.8). Inscription (lower right): "W. G./per I. G." Provenance: Mr. Ira Glackens, Kraushaar Galleries, New York, Mr. and Mrs. William M. Fuller, Marcia Fuller French.

world, and had been patronized by American collectors until the wave of dependence on European culture swept the country in the years following the Civil War. It may be that the 1890s saw the return of the collectors' and general public's interest in this American depiction of light, against the background of the acceptance of a modern French style whose only subject was light and its reflection. Despite the successful career of an artist such as John Twachtman, young American artists felt the restrictive pressures of the dominant organization, the National Academy of Design. The lack of a network of competing organizations or dealers' galleries left little opportunity outside the established channels of the Academy's annual juried exhibitions for showing works, and thus of finding patronage or a sympathetic public.

The Society of American Artists had been formed in 1877 but provided little force against the powerful Academy; the two groups were merged in 1906. Partially out of dissatisfaction with the Society, and seeking other means of exhibiting their paintings with congenial artists, John Twachtman, J. Alden Weir, and Childe Hassam, joined by seven other artists, resigned from the Society in 1897. The following year the ten artists exhibited together at Durand-Ruel's gallery, establishing a tradition for that group (William Merritt Chase took Twachtman's place upon the latter's death in 1902) that was to continue for twenty years. Within ten years of its first exhibition the artists who had come to be called "The Ten" found themselves in the position of restricting, by virtue of their limited membership, the exhibition possibilities of a younger group of artists, who would themselves seek an identity by exhibiting at another dealer's gallery in New York.

Frederick Childe Hassam was the strongest personality within "The Ten." Whereas John Twachtman and his art were quiet and reserved, Hassam's personal and artistic style was forceful and direct. A friend of Twachtman who often visited the Greenwich farm, Hassam never painted landscapes that approached the subjectivity of Twachtman's. Instead, Hassam's interest in painting changing weather conditions was more for the spectacular visual effects that could be achieved than the opportunity for solitary contemplation. As with Twachtman, study at the Académie Julian was part of Hassam's Parisian training. Like Robinson, he quickly came under the influence of the Impressionists. He lightened his palette and simulated the broken brushstroke that clearly marked one method of Impressionist paint application. Hassam approached the technique of Monet and Pissarro more closely than the other Americans, yet his paintings show the enjoyment of

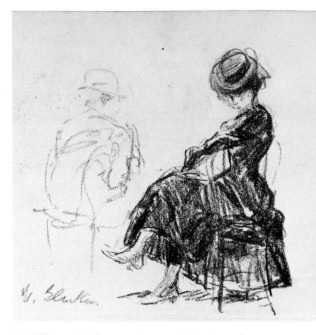

9. William Glackens, *Woman with Crossed Knees*. Charcoal on paper, 5 x 8-3/8 in. (13.4 x 21.3). Inscription (lower left): "W. Glackens." Provenance: Mr. Ira Glackens, Kraushaar Galleries, New York, Mr. and Mrs. William M. Fuller, Adelaide Fuller Biggs.

the strokes for their decorative effect rather than for the purpose of depicting the dissolution of light. Like Robinson as well, Hassam always maintained a strong sense of composition and subject, identifiably American characteristics.

Following his important second European trip of study and painting in France (1886-1888) Hassam turned from an earlier interest in gray days in the city to the direct sunlight of the country scene. *The Mackerel Schooner, Gloucester* (figure 11) and *Old Hook Mill, Easthampton* (figure 12), both painted in the late 1890s, take full advantage of the artist's experience painting *en plein air* and facility with pointillist technique. Both Gloucester and Easthampton were favorite spots for American artists, and many spent summers pleasantly painting the picturesque sea towns of Massachusetts and Long Island. Hassam was as involved as Robinson in the evocation of a specific place, but usually under the brightest sun the day could offer. His was a positive and optimistic art of one for whom the beauty of his technique and color sense was perfectly suited to the location he chose to paint. Unusual for Hassam was the choice of a scene of labor. *The Laborer* of 1900 (figure 10) is more in the tradition of Camille Pissarro, for whom such scenes had meaning as commentary upon the working class. We can feel no

such social concern on Hassam's part, and must conclude that he was drawn to the subject for its picturesque possibilities and its relationship to paintings by French Impressionists like Pissarro. By 1894, when Hamlin Garland championed the Impressionists in *Crumbling Idols*, Hassam could be described perfectly by Garland's dictum: "Let the American artists abandon the dull mists of the Lowlands and the North Sea and learn from the impressionists how to paint a June day in New England." This positive acceptance of American life and values is one side of the 1890s, and of all the artists Hassam best expresses the optimism generated by certain segments of the society in which he moved so easily. His paintings found a ready audience in America as they had during his Parisian days.

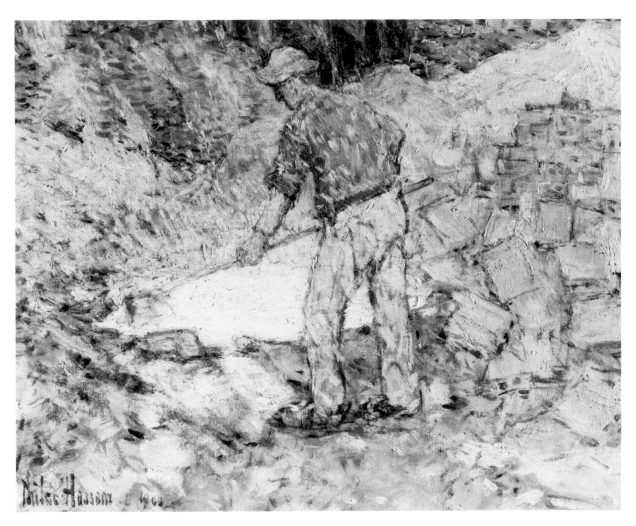

10. Frederick Childe Hassam (1859-1935), *The Laborer*. 1900. Oil on canvas, 13 x 16-1/4 in. (33.0 x 41.3). Inscription (lower left): "Childe Hassam 1900." Provenance: George Shaw, Greenwood Lake, New York, The Milch Galleries, New York, Mr. and Mrs. William M. Fuller, Adelaide Fuller Biggs.

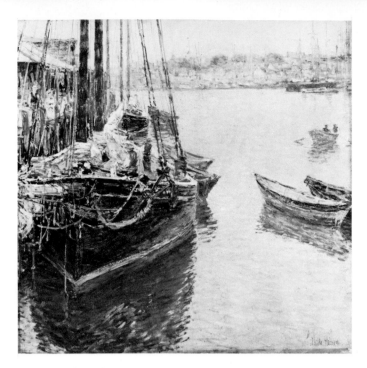

11. Frederick Childe Hassam, *The Mackerel Schooner, Gloucester*. 1896. Oil on canvas, 20-1/8 x 20-1/4 in. ()1.1 x 51.4). Inscription (lower right): "Childe Hassam 1896." Provenance: The Milch Galleries, New York, The Fuller Foundation.

Trips to New England were Hassam's summer excursions, for his home was the city, first Boston and then New York. To the painting of American city scenes he brought the charm of Paris and beauty of the countryside. Indeed, the city views chosen by Hassam were usually those of a park where residents enjoyed pleasures of simulated country life. *Union Square and 16th Street, New York* (figure 14) is Hassam's New York, a city of leisurely pursuits and bright, clear days where nature and the urban environment are harmoniously united.

By the time Hassam was painting his version of New York, other artists were finding a very different city to paint. One need only compare *Union Square and 16th Street, New York* (figure 14) to Everett Shinn's *Park Row, Morning Papers* (figure 54) or *Old Hook Mill, Easthampton* (figure 12) to William Glackens' *Coney Island* (figure 5) to see that Americans of the turn of the century had opposite views of the city and its country retreats. The 1890s, years of success for John Twachtman and Childe Hassam, were years of struggle for four young Philadelphia artists who were to provide the core of the group called "The Eight." These artists — John

Sloan, William Glackens, Everett Shinn, and George Luks — came under the influence of Robert Henri, who encouraged them to devote themselves seriously to painting and move to New York, the art capitol of America. But first they were newspaper artists, skilled in quickly identifying an interesting subject in the city and sketching it for publication in newspapers such as the Philadelphia *Press*, for which all of them at one time worked.

Robert Henri alone in the group did not work for the papers or magazines, but followed in his early career a path not unlike the American Impressionists of his generation. He particularly admired the work of Twachtman, but significantly enough was a student in Philadelphia rather than New York, having settled in New Jersey with his family following his father's brush with the law that forced the young Robert Henry Cozad to change his name to Robert Henri. Study at the Pennsylvania Academy of the Fine Arts was far different from that at the National Academy of Design in New York, chiefly due to the presence of Thomas Eakins, whose

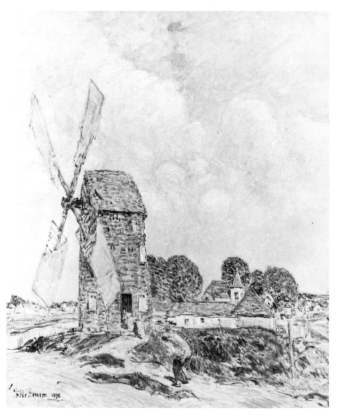

12. Frederick Childe Hassam, *Old Hook Mill, Easthampton*. 1898. Oil on canvas, 30 x 25 in. (76.2 x 63.5). Inscription (lower left): "Childe Hassam 1898." Provenance: William Macbeth, New York, Kennedy Galleries Inc., New York, James Graham & Sons Galleries, New York, Mr. and Mrs. William M. Fuller.

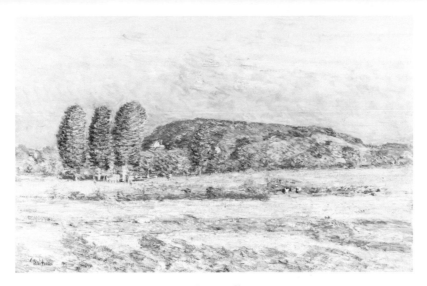

13. Frederick Childe Hassam, *Stratham Hill — Near Exeter, New Hampshire*. 1907. Oil on canvas, 20-1/8 x 30-1/4 in. (51.1 x 76.8). Inscription (lower left): "Childe Hassam 1907." Provenance: The Milch Galleries, New York, Dr. and Mrs. H. C. Scobey, New York, The Milch Galleries, New York, Mr. and Mrs. William M. Fuller, Adelaide Fuller Biggs.

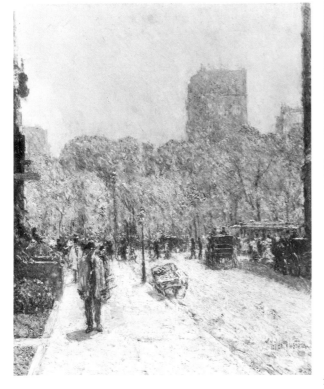

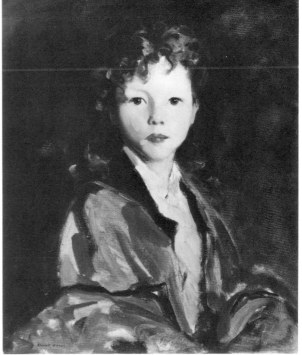

14. Frederick Childe Hassam, *Union Square and 16th Street, New York*. 1890s. Oil on canvas, 18 x 14 in. (45.7 x 35.6). Inscription (lower right): "Childe Hassam." Provenance: William Macbeth, New York, Giovanni Castano, Boston, Massachusetts, Hirschl & Adler Galleries Inc., New York, Mr. and Mrs. William M. Fuller.

15. Robert Henri (1865-1929), *Portrait of Jean McVitty*. Oil on canvas, 24 x 20 in. (60.9 x 50.8). Inscription (lower left): "Robert Henri." Provenance: McFadden Estate, Fort Worth, Mr. and Mrs. William M. Fuller.

advocacy of contemporary subject matter, importance of portraiture, and study of anatomy from life drawing rather than plaster casts was renowned. Some of Eakins' teaching methods were so controversial that he had been forced to resign his teaching position the year before Henri enrolled. Nevertheless, Eakins' philosophy was continued by his pupil, Thomas Anshutz, and Henri's early aptitude for portraiture and subjects of daily life can be traced to his early teacher.

Like many of his fellow art students Henri desired European training, and he set off for Paris in 1888 to study at the Académie Julian. During the next twelve years he traveled back and forth to Europe, visiting Italy, Holland, and Spain, but spending much of his time in Paris. Two of the Henris in the Fuller collection are French scenes, one a sketch of Paris, *Looking Across the Seine from the Right Bank* (figure 16), the other, *The White Schooner, Concarneau* (figure 17), painted during one of three trips (in 1889, 1894, and 1899) to that small coastal village in Brittany. Henri was fascinated by the local color of the place and took the opportunity to paint the fishing vessels of the Atlantic inlet *en plein air*

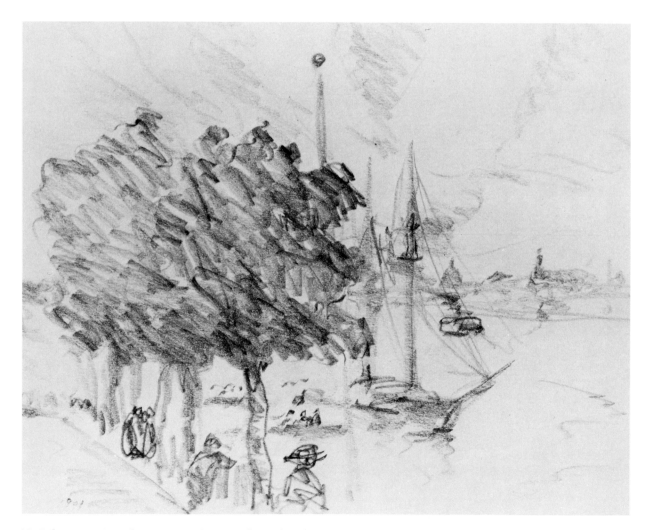

16. Robert Henri, *Looking Across the Seine from the Right Bank*. 1901. Pencil on paper, 7-7/8 x 9-7/8 in. (19.7 x 24.7). Inscription (lower left): "1901." Provenance: Estate of the artist, Bernard Black Gallery, New York, Mr. and Mrs. William M. Fuller.

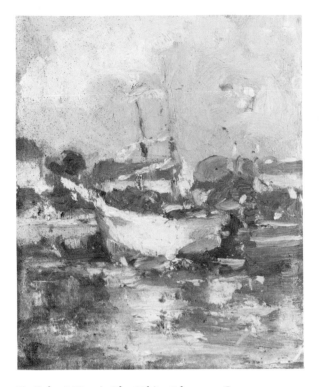

17. Robert Henri, *The White Schooner, Concarneau*. 1890s. Oil on wood panel (cigar box top), 6-3/8 x 4-7/8 in. (16.0 x 12.4). Provenance: Estate of the artist, Hirschl & Adler Galleries Inc., New York, Mr. and Mrs. William M. Fuller.

on a small panel or cigar box top. Henri did not continue in the mode of a landscape painter, but instead returned to America and gathered around him students of a new, more direct approach to the contemporary scene. Apart from his teaching Henri's own painting in the years after his European stay was greatly influenced by his admiration of Velasquez, Hals, and Manet. These great masters of portraiture provided inspiration for the American artist to capture directly the personality of his sitters, such as the young boy *Jean McVitty* (figure 15), through the quick application of paint with a heavily loaded brush.

The theme of contemporary life was not new to American artists. But the acceptance of all aspects of life — rich and poor, and especially urban — was new to the American public. Authors like Upton Sinclair, Jacob Riis, Stephen Crane, and Frank Norris had shown no reluctance to write about previously unacceptable subjects in the spirit of social reform. And now artists, under no direct influence of authors, would broach similar subjects. A few, notably John Sloan, would embrace international socialism. The majority would not, and their paintings, including Sloan's, represent concern for the common man rather than a dogmatic philosophy. "The Eight," as they came to be known, joined in accepting the new industrial life and showing sympathy for the plight of the common man whose life was inextricably bound to the new order. This

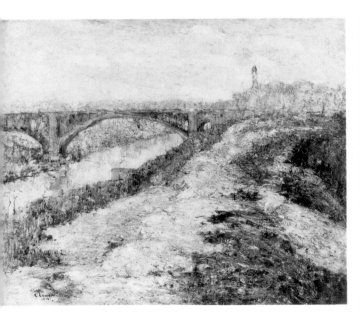

18. Ernest Lawson (1873-1939), *High Bridge, Harlem River*. 1918. Oil on canvas, 25 x 30 in. (63.5 x 76.2). Inscription (lower left): "E. Lawson./1918." Provenance: Marion Maguire, New York, James Preston, New York, James Graham & Sons Galleries, New York, Mr. and Mrs. William M. Fuller.

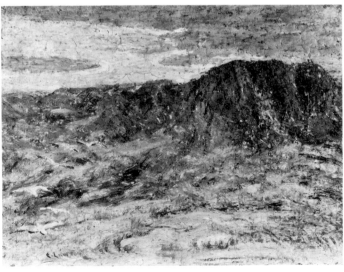

19. Ernest Lawson, *In from the Sea*. Oil on canvas, 12 x 16 in. (30.5 x 40.6). Inscription (lower left): "E. Lawson." Provenance: Ferargil Galleries, New York, Davis Galleries, New York, Mr. and Mrs. William M. Fuller.

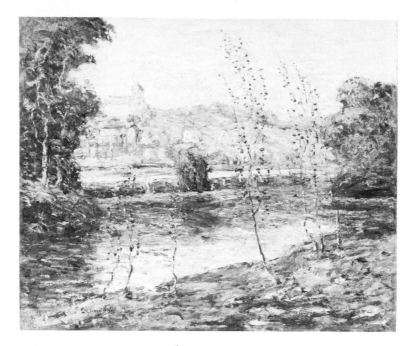

20. Ernest Lawson, *Spring Landscape*. Oil on canvas, 25 x 30 in. (63.5 x 76.2). Inscription (lower left): "E. Lawson." Provenance: Private Collection, Kennedy Galleries Inc., New York, Mr. and Mrs. William M. Fuller, Adelaide Fuller Biggs.

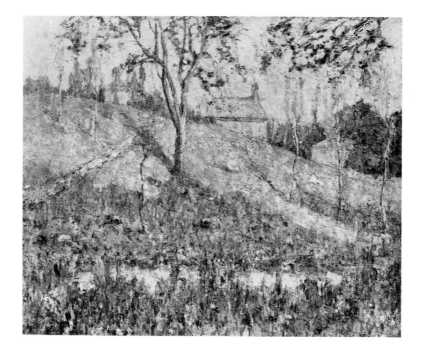

20a. Ernest Lawson, *Woodland Scene*. 1913. Oil on canvas, 25 x 30 in. (63.5 x 76.2). Inscription (lower right): "E. Lawson./1913." Provenance: Marion Maguire, New York, James Graham & Sons Galleries, New York, Private Collection, New York, Mr. and Mrs. William M. Fuller.

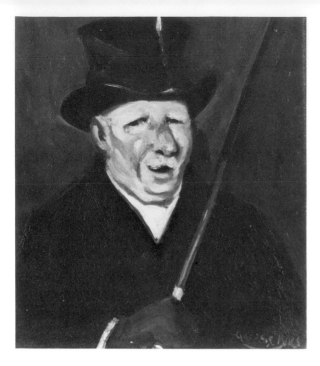

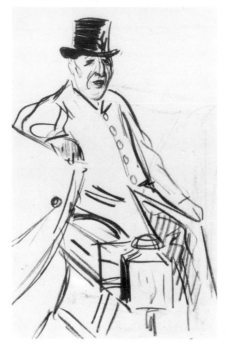

21. George Luks (1867-1933), *The Cabby*. Oil on wood panel, 9-3/4 x 8-1/4 in. (24.8 x 21.0). Inscription (lower right): "George Luks." Provenance: Newhouse Galleries Inc., New York, Hirschl & Adler Galleries Inc., New York, Mr. and Mrs. William M. Fuller.

22. George Luks, *The Cabby* (study for). Charcoal on paper, 6-3/4 x 4-1/4 in. (17.2 x 10.8). Provenance: Caroline Luks, Fenn Galleries Ltd., Santa Fe, New Mexico, Mr. and Mrs. William M. Fuller.

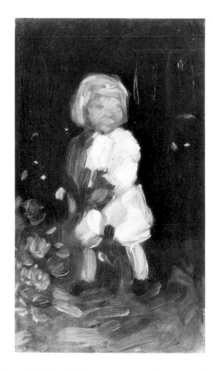

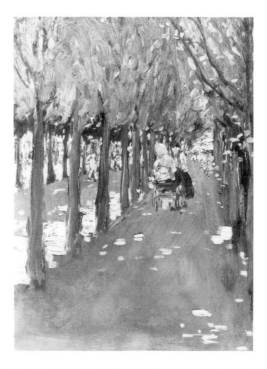

23. George Luks, *Child in Pink Rompers*. Oil on wood panel, 7-3/8 x 4-1/4 in. (18.7 x 10.8). Provenance: Miss Sylvia Saunders, Clinton, New York, Kraushaar Galleries, New York, Mr. and Mrs. William M. Fuller.

24. George Luks, *Luxembourg Gardens, Paris*. c. 1902. Oil on wood panel, 8-3/8 x 6-1/8 in. (21.3 x 15.6). Inscription (verso): "George Luks." Provenance: John F. Braun Collection, Mr. and Mrs. T. E. Hanley Collection, J. Welch Collection, Kraushaar Galleries, New York, Mr. and Mrs. William M. Fuller.

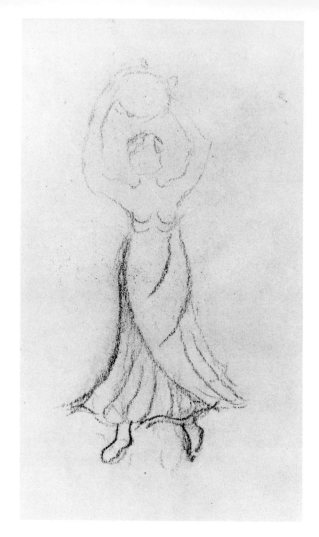

25. Charles Prendergast (1863-1948), *Dancer*. 1927. Charcoal on paper, 9-5/8 x 5-3/8 in. (24.4 x 13.6). Provenance: Mrs. Charles Prendergast, Westport, Connecticut, Mr. and Mrs. William M. Fuller.

their work as newspaper artists and illustrators, all seeking new avenues for the exhibition of their paintings.

Life in New York proved an exciting stimulus to their work. Shinn's *Park Row, Morning Papers* (figure 54) gives an idea of the setting and the intensity with which the group approached life and art. Shinn wrote on the back of the drawing: "Park Row. Morning Papers. Newsboys. Trucks — ink damp bundles of news — the first lusty breath of a new day. The building in the background — the old World building. There I worked in the Art department." Stylistically, each had formed a personal adaptation of the teachings of Anshutz and Henri which now could be applied to new themes of the city. George Luks particularly liked to paint city characters whose lives often mirrored his own — both real and imaginary. *The Cabby* (figure 21) brings to mind rough, boisterous carriage drivers around Central Park, where he also might have observed the steps of the charming *Child in Pink Rompers* (figure 23), whose body and playsuit are boldly brushed in individual strokes. Although he traveled and painted in Europe and found the Luxembourg Gardens a source for several small panels (figure 24), Luks was more at home with his American personalities, around whose lives the city was shaped.

spirit of reform, general rather than specific, was associated with Theodore Roosevelt's second Presidential term.

Experience as a newspaper reporter-illustrator provided perfect training for an artist who chose to paint contemporary life. Friends on the newspapers, Sloan, Glackens, Luks, and Shinn, would meet at Henri's studio in Philadelphia to paint together and exchange ideas. Henri moved in 1900 to New York, where Shinn, Glackens, and Luks had settled in the years just prior to the turn of the century. By 1904 the five artists were all living in that city, some continuing

26. Charles Prendergast, *Fantasy*. 1917. Pencil, tempera, gold and silver leaf on carved wood panel, 19-3/4 x 21-3/4 in. (50.2 x 55.3). Inscription (lower left): "CP" [monogram]. Frame by Charles Prendergast. Provenance: Dr. Albert C. Barnes, Merion, Pennsylvania, Mr. and Mrs. John C. Marin, Jr., Kraushaar Galleries, New York, Mr. and Mrs. William M. Fuller.

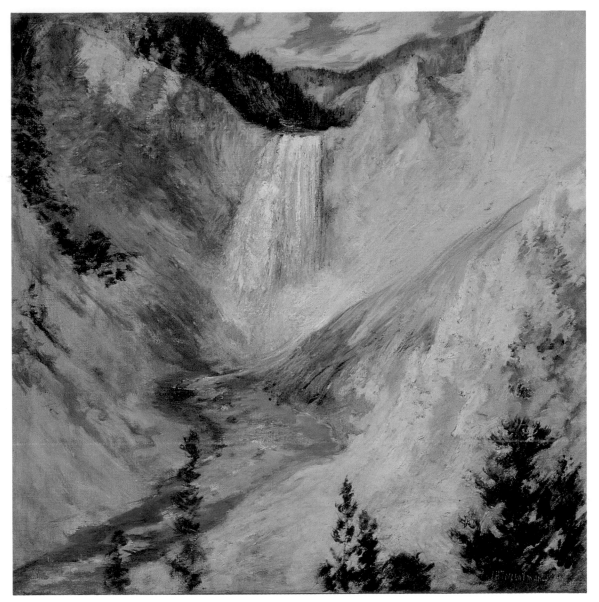

John H. Twachtman
Lower Falls, Yellowstone (figure 58)

Ernest Lawson
High Bridge, Harlem River (figure 18)

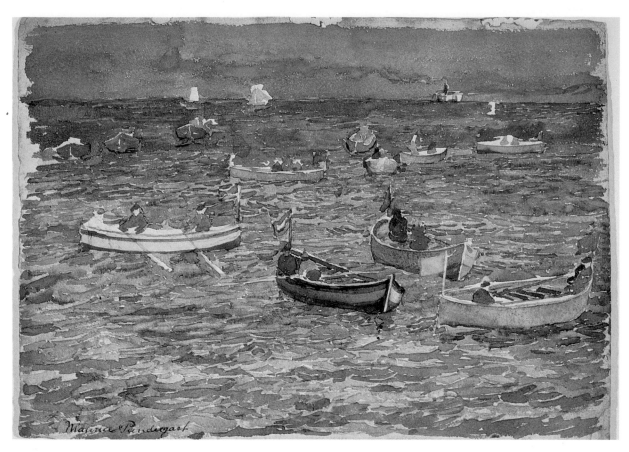

Maurice Brazil Prendergast
Along the Shore — St. Malo (figure 31)

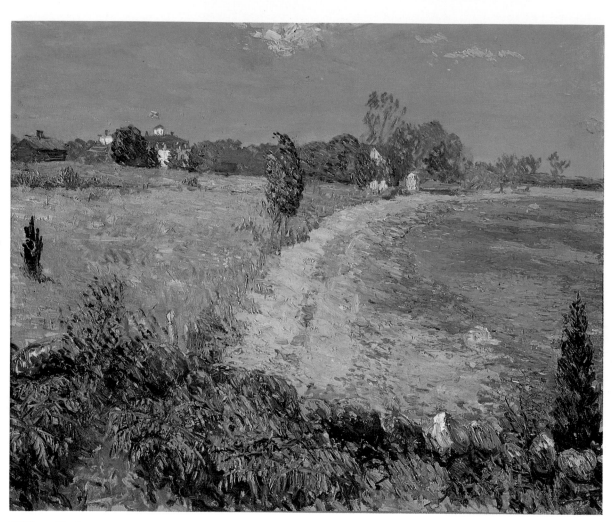

William Glackens
Curving Beach, New England (figure 6)

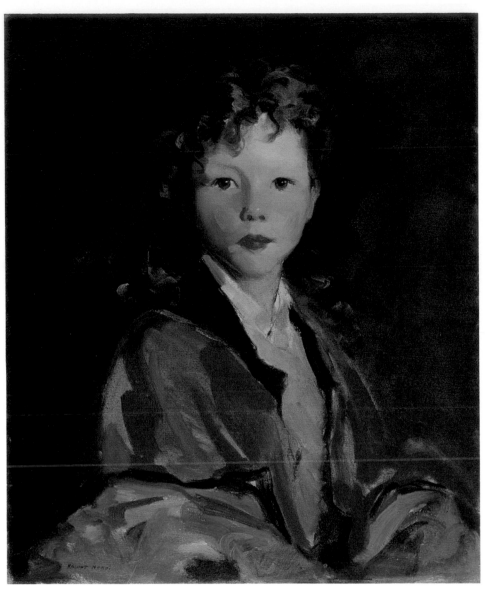

Robert Henri
Portrait of Jean McVitty (figure 15)

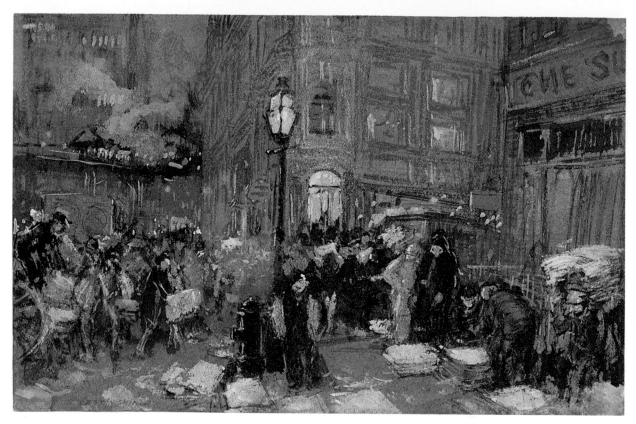

Everett Shinn
Park Row, Morning Papers (figure 54)

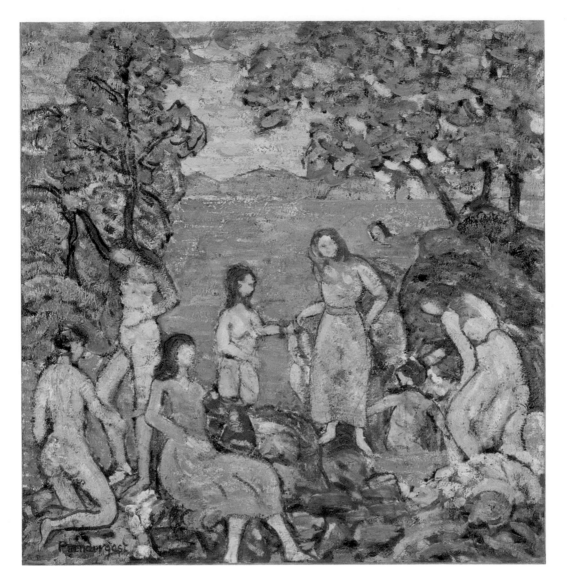

Maurice Brazil Prendergast
Bathers in a Cove (figure 32)

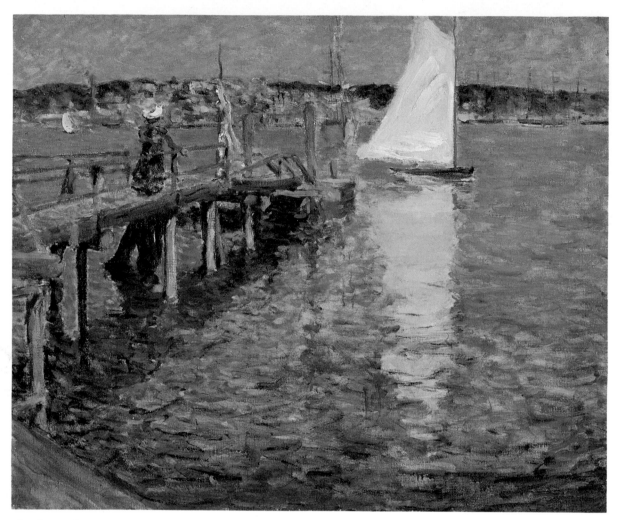

Theodore Robinson
The Anchorage, Cos Cob, Connecticut (figure 50)

Charles Prendergast
Fantasy (figure 26)

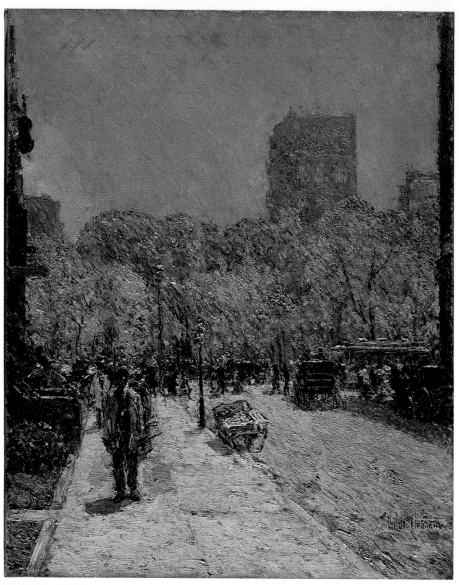

Frederick Childe Hassam
Union Square and 16th Street, New York (figure 14)

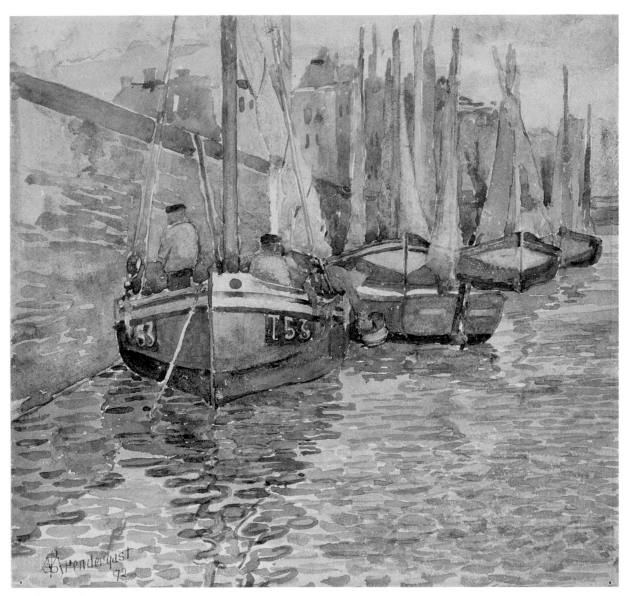

Maurice Brazil Prendergast
Fishing Boats, Normandy (figure 38)

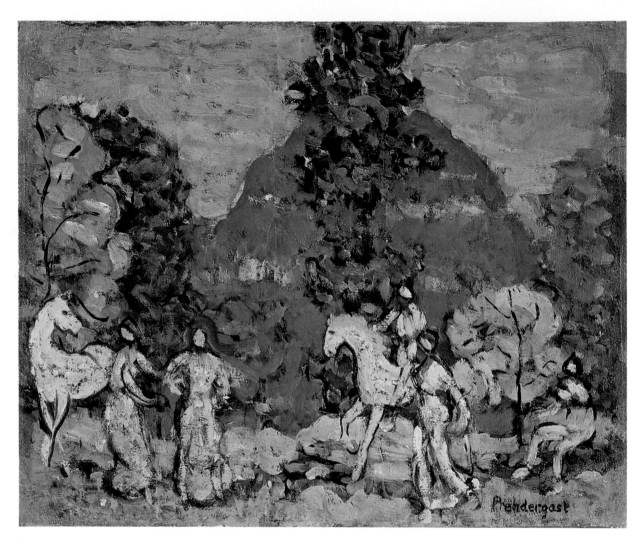

Maurice Brazil Prendergast
Edge of the Grove,
or *At the Foot of the Blue Mountain* (figure 37)

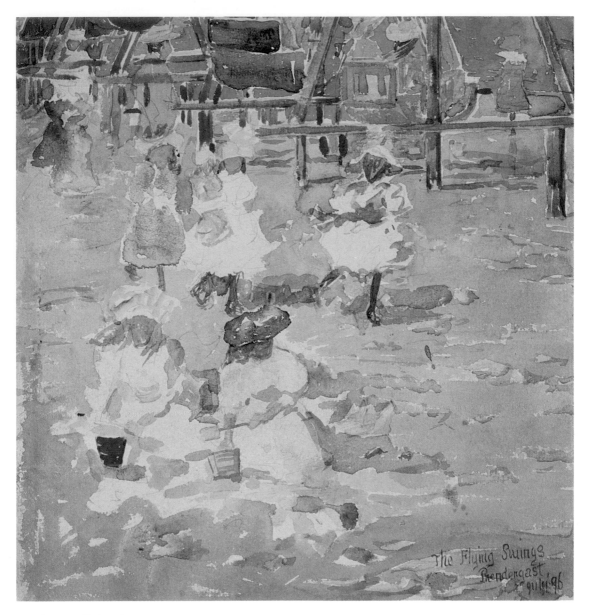

Maurice Brazil Prendergast
The Flying Swings (figure 40)

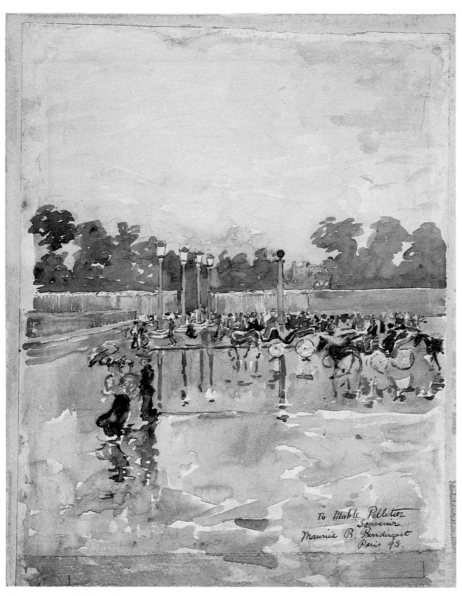

Maurice Brazil Prendergast
Paris Boulevard in the Rain (figure 41)

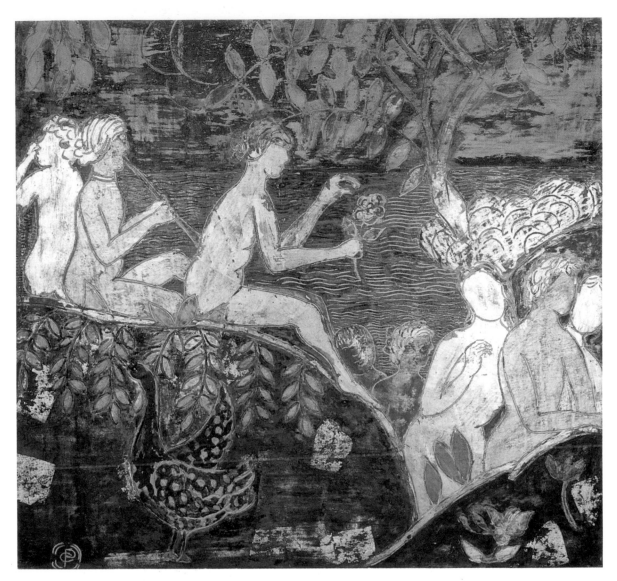

Charles Prendergast
Idyllic Scene (figure 29)

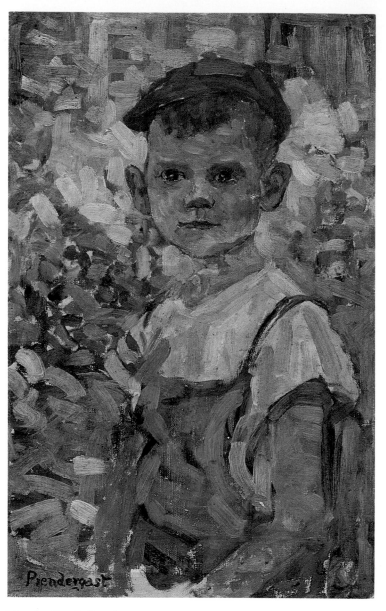

Maurice Brazil Prendergast
Boy with Red Cap (figure 34)

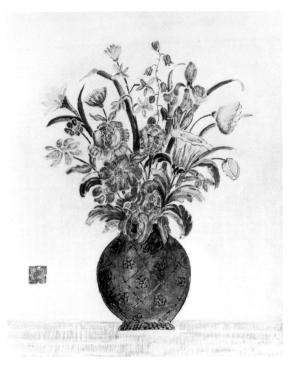

New York carried a different meaning for each member of the group. To Shinn it was a city of night life, especially the world of the theater, for which he designed and painted sets, wrote, and acted. He mastered the depiction of artificial light, often achieved through the mixing of watercolor and pastel as had Edgar Degas, the French Impressionist most admired by Shinn. A trip to Paris in 1900 established visual images he called upon for years following the visit. Two of these, *Paris Cabaret Singers* (figures 52 and 53), which were framed by the artist's patron and collaborator in architectural decoration, Stanford White, are in the Fuller collection. Seen above the heads of the crowd, the show girls are reminiscent of Degas' figures and the inhabitants of the Parisian world of Georges Seurat. Unlike Seurat, whose immobile figures of Parisian evenings only shimmer through brushstrokes or crayon marks, Shinn presents the active, noisy world of the street typical of the best images of "The Eight."

Shinn's association with the theater assured him a certain life style and even success for his paintings. No such opportunity was taken by John Sloan, whose struggle for recognition continued even after the beginning of a long association with the dealer John Kraushaar. Sloan was the last of the Philadelphia artists to come to New York, and the last to take up oil painting. One of his earliest oils is in the Fuller

27. Charles Prendergast, *Flowers in a Persian Vase*. 1935. Pencil, tempera, and gold leaf on carved masonite, 19-1/8 x 15-1/8 in. (46.3 x 38.7). Inscription (lower left): "CP" [monogram]. Provenance: Mrs. Charles Prendergast, Westport, Connecticut, Mr. and Mrs. William M. Fuller.

28. Charles Prendergast, *Golden Fantasy*. After 1930. Pencil, tempera, and gold leaf on carved wood panel, 15-1/8 x 28-3/8 in. (38.4 x 72.1). Frame by Charles Prendergast. Provenance: Mrs. Charles Prendergast, Westport, Connecticut, Mr. and Mrs. William M. Fuller.

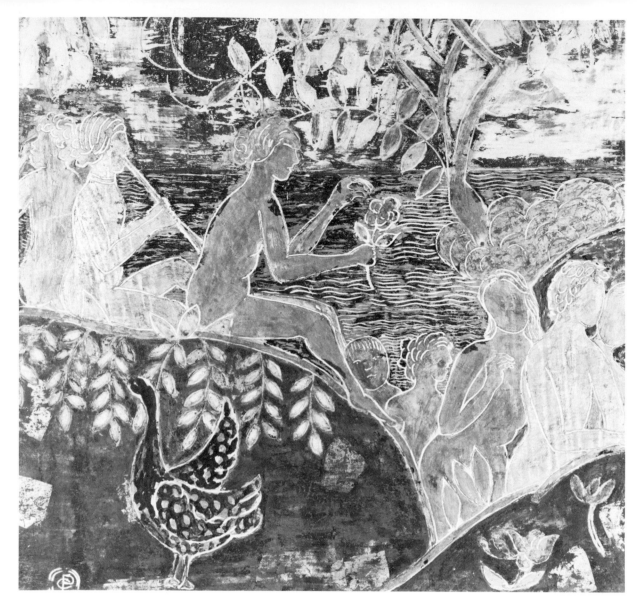

29. Charles Prendergast, *Idyllic Scene*. Pencil, tempera, and gold leaf on carved wood panel, 12 x 12-3/4 in. (30.5 x 32.3). Inscription (lower left): "CP" [monogram]. Frame by Charles Prendergast. Provenance: Estate of Walt Kuhn, Kennedy Galleries Inc., New York, Mr. and Mrs. William M. Fuller.

collection, the *Portrait of James Preston* (figure 56), fellow artist-reporter on the Philadelphia *Press* and member of the group around Henri in Philadelphia. Here in Sloan's portrait is Henri's dark palette and direct method of capturing characterization. Despite encouragement from Henri, Sloan did not go abroad, never seeming to tire of the endless variety life in New York offered. The city itself spirited Sloan to new work, and by 1905-1906 he was sketching for a series of etchings of city life, reflected in the vignette of the

Dog Show #1 (figure 55). Of all "The Eight," Sloan's paintings and sketches come closest to fitting the epithet "Ashcan School," later derogatorily applied to the realism of their subjects.

William Glackens saw beauty in the common event of daily life as did John Sloan, and the acceptance of such subjects as desirable for American artists owes much to the example of these two artists. The joyous side of city life — evenings spent at Chez Mouquin or the Café Francis, Sunday

30. Charles Prendergast, *St. Paul de Vence (#1)*. 1927.
Pencil and watercolor on paper, 8-3/4 x 12-5/8 in. (22.2 x
32.1). Inscription (lower left): "CP per E. P." Prove-
nance: Mrs. Charles Prendergast, Westport, Connect-
icut, Mr. and Mrs. William M. Fuller.

31. Maurice Brazil Prendergast (1859-1924), *Along the
Shore — St. Malo*. c. 1898. Pencil and watercolor on
paper, 11 x 15-1/2 in. (27.9 x 39.3) irregular. Inscription
(lower left): "Maurice Prendergast." Provenance: Mrs.
Charles Prendergast, Westport, Connecticut, Mr. and
Mrs. William M. Fuller.

afternoons at Coney Island — were Glackens' subjects. The sweep and activity of a street in *New York* (figures 7 and 8) are drawn with the vitality and force of an artist who loved to record the passing scene. Later in his career, Glackens came to admire the paintings of Auguste Renoir, the French Impressionist whose work is closest to a traditional concept of beauty. Glackens not only emulated the bright palette of the French artist, as in *Curving Beach, New England* (figure 6), but purchased Renoirs for his friend Albert C. Barnes, patron of Glackens and other members of "The Eight."

Glackens was the common link among the loosely knit group of artists who emigrated from Philadelphia to New York. He attended high school with Albert C. Barnes and John Sloan, was a close friend of Shinn, traveled to Paris and the Low Countries with Robert Henri in 1895, and shared a studio with George Luks in 1900. Later he would introduce Charles and Maurice Prendergast to the others. Ernest Lawson, a native of Nova Scotia who lived in Canada and France, settled in New York in 1898 and was invited by Glackens to join the group that met at Mouquin's and the Café Francis.

Different from others of "The Eight," Lawson took his subjects from the outskirts of the city near his home, along the Hudson and Harlem Rivers north of New York. The only true landscapist of the group, Lawson was a quiet and private man whose style conveyed a personal communication with certain favorite themes. In this way his work was similar to that of John Twachtman, whom Lawson greatly admired and to whom he is often compared. He painted the High Bridge, spanning the Harlem River (figure 18), over and over again, thickly applying paint in many layers and varying his choice of pigments with different seasons and times of day. He often worked over one canvas to the extent that it appears encrusted with luminous color.

The group was a disparate one with a thematic unity shared only by the Philadelphia artists, but the stage was set for an exhibition that has become a symbol of independence from academic constrictions. In the early years of the twentieth century the young Realist artists continued to seek means to exhibit their work. The Society of American Artists, which had accorded them limited support, in 1906 was merged with the National Academy of Design, from which it had broken almost thirty years before. Although Henri had been elected a full member of the Academy, and Lawson and Glackens associate members, they felt that the organization was not responsive enough to the needs of their group and they determined to find an alternate mode to exhibit their paintings. They convinced dealer William Macbeth, whose gallery had been showing American art since it opened in 1892, to let them organize an exhibition. In 1908, for the first and only time, Henri, Sloan, Glackens, Luks, Shinn, and Lawson, joined by Arthur B. Davies and Maurice Prendergast, exhibited together. The success of the show may have been helped by some of the negative coverage it received in the press. The conservative art critics had little sympathy for paintings that dealt as directly in a realistic style with all aspects of contemporary life. But the public came in force, and the exhibition even realized a good profit for many of the artists. The popular and, in some arenas, critical success, can be judged by the subsequent tour of the exhibition to Philadelphia, Chicago, Detroit, Toledo, Pittsburgh, Cincinnati, Bridgeport, and Newark, with purchased paintings replaced along the way.

The bold subject matter of the Philadelphia artists was most visible and readily identifiable as new to the critics, but the work of two others whose preoccupation was with style rather than theme must have seemed even stranger. It is these artists, Davies and Maurice Prendergast, who would herald the near future of revolution in a sphere outside subject matter.

During the 1890s, when the Philadelphia artists were beginning to paint the city, Davies was absorbed with highly personal allegories and fantasies. He

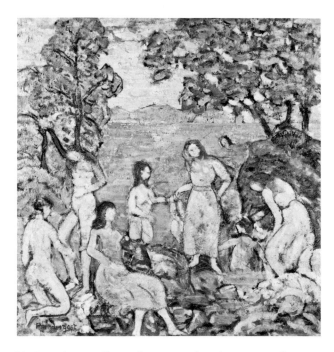

32. Maurice Brazil Prendergast, *Bathers in a Cove*. Oil on canvas, 27-1/8 x 26-1/8 in. (68.9 x 66.3). Inscription (lower left): "Prendergast." Provenance: Mrs. Charles Prendergast, Westport, Connecticut, Kraushaar Galleries, New York, Mr. and Mrs. William M. Fuller.

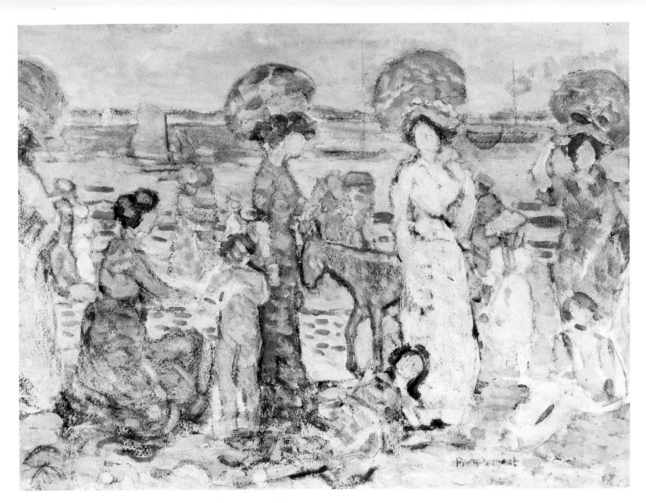

33. Maurice Brazil Prendergast, *Beach Promenade*. 1915. Pencil, pastel, watercolor, and oil on paper, 15-1/2 x 19-3/4 in. (39.4 x 50.1). Inscription (lower right): "Prendergast." Verso: Untitled [red flowers in a vase], pencil, pastel, and watercolor. Provenance: Mrs. Charles Prendergast, Westport, Connecticut, Mr. and Mrs. William M. Fuller.

came under the influence of Whistler, evident in the mysterious portrait entitled *The Whisperer* (figure 4), and in evocative tonal landscapes keynoted by unusual effects of light at night in *Fire on Beach* (figure 2), or late afternoon in *The Swimmers* (figure 3). Davies was patronized by important collectors of modern American art, among them Lillie P. Bliss and Mrs. John D. Rockefeller, Jr. His association with modern art in America and Europe became more important than his position as fellow exhibitor with "The Eight," for within a few years American artists who looked to contemporary, more abstract European art would be in the forefront. Davies became the second president of the Association of American Painters and Sculptors, formed in 1911. Through his foresight, perception, and hard work the International Exhibition of Modern Art was accomplished within two years and

opened at the 69th Regiment Armory in 1913. In that year, Davies painted *Eye Beams* (figure 1), a figural study examining the abstract color and rhythm patterns he recently had discovered in Cubism.

Interests in the purely national aspects of modern art, upheld by Robert Henri and John Sloan (both of whom were active in the early stages of planning the Armory Show), had been defeated by those who recognized that art should have no regional boundaries. Often called the only American Post-Impressionist, Maurice Prendergast's artistic sensibility developed over years of travel in Europe. There he responded to a wide variety of stimuli — from Byzantine and Renaissance painting to contemporary works of early twentieth-century French artists. In some ways Prendergast was like Arthur B. Davies. An outsider to the group of Philadelphians, he did not move to New York until

1914, although he had frequently visited that city and in 1904 exhibited with Davies, Henri, Sloan, Glackens, and Luks at the National Arts Club. As with many of "The Eight," Glackens introduced Maurice Prendergast and his brother Charles to the others and encouraged their participation in New York exhibitions.

The Prendergasts lived and worked in Boston where the family had moved from Newfoundland. Charles was a woodworker who, at the encouragement of his older brother, began a career as a frame maker in 1895. He often traveled to Europe, absorbing in particular medieval and Renaissance Venetian paintings. Following a stay of 1911-1912 in Italy, Charles began to carve, gesso, and paint panels, inspired by Maurice's example, but developing a style and subject matter that was

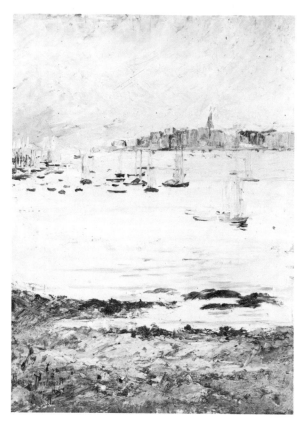

35. Maurice Brazil Prendergast, *Dinard, View of St. Malo*. 1891. Oil on wood panel, 13-3/4 x 10-1/4 in. (34.9 x 26.0). Inscription (lower left): "Maurice Prendergast/Dinard/'91." Provenance: Mrs. Charles Prendergast, Westport, Connecticut, Mr. and Mrs. William M. Fuller, Adelaide Fuller Biggs.

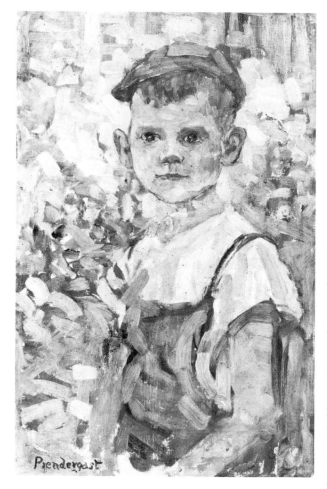

34. Maurice Brazil Prendergast, *Boy With Red Cap*. 1912. Oil on canvas, 15-1/8 x 9-1/4 in. (38.4 x 23.5). Inscription (lower left): "Prendergast." Provenance: Mrs. Charles Prendergast, Westport, Connecticut, Mr. and Mrs. William M. Fuller.

intensely personal. A consummate craftsman, Charles took great pleasure in the fabrication of his works, applying gold and silver leaf to the carved, gessoed, and painted panels. The resultant paintings are fanciful and dreamlike, inhabited by figures and animals worthy of their inspiration in the Persian miniatures, Byzantine mosaics, and early Italian panel paintings he admired. Even when he drew a specific scene, such as *St. Paul de Vence* (figure 30), Charles organized the composition into an insistent pattern that conformed as much to the two-dimensional support as to the original impetus for the work.

In Charles Prendergast's panel paintings actual depth is achieved through incising and carving the wood itself and by the reflections of gold and silver leaf. Figures and landscape elements completely fill the surface, as in *Idyllic Scene* (figure 29) and *Fantasy* (figure 26), or are scattered nonillusionistically over the ground in *Golden Fantasy* (figure 28). They portray an enchanted and

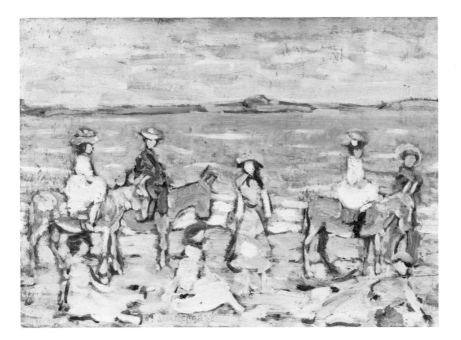

36. Maurice Brazil Prendergast, *Donkey Riders*. 1912.
Oil on wood panel, 11 x 15 in. (27.9 x 38.1). Inscription
(lower center): "Prendergast." Provenance: Mrs.
Charles Prendergast, Westport, Connecticut, Mr. and
Mrs. William M. Fuller.

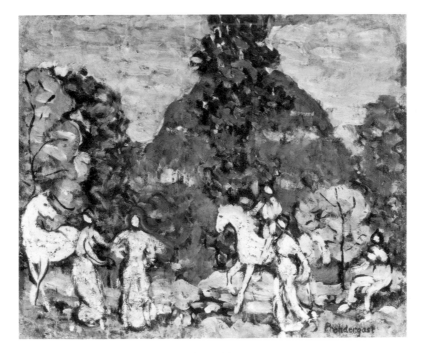

37. Maurice Brazil Prendergast, *Edge of the Grove*, or
At the Foot of the Blue Mountain. 1919. Oil on canvas,
17-1/4 x 21-1/8 in. (43.9 x 53.7). Inscription (lower right):
"Prendergast." Provenance: Mrs. Charles Prendergast,
Westport, Connecticut, Mr. and Mrs. William M. Fuller.

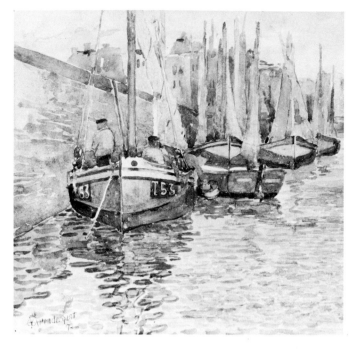

38. Maurice Brazil Prendergast, *Fishing Boats, Normandy*. 1892. Pencil and watercolor on paper, 8-1/4 x 8-5/8 in. (20.9 x 21.9). Inscription (lower left): "MBP [monogram] rendergast/92." Provenance: Mrs. Charles Prendergast, Westport, Connecticut, Kraushaar Galleries, New York, Mr. and Mrs. William M. Fuller, Adelaide Fuller Biggs.

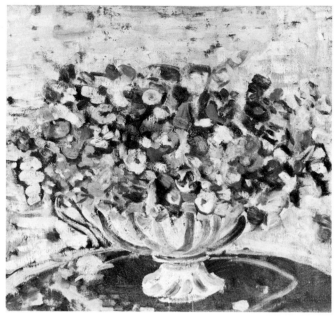

39. Maurice Brazil Prendergast, *Flowers in a Bowl*. Oil on canvas, 16-1/2 x 18-1/2 in. (41.9 x 47.0). Inscription (lower right): "Prendergast." Provenance: Whitney Museum of American Art, New York, Mr. Ralph Wilson, Kraushaar Galleries, New York, Mr. and Mrs. William M. Fuller.

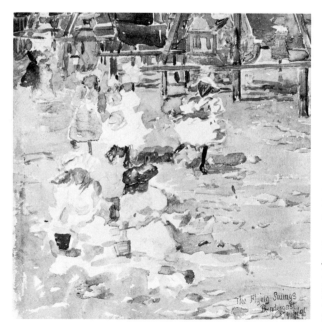

40. Maurice Brazil Prendergast, *The Flying Swings*. 1896. Pencil and watercolor on paper, 10 x 9-1/2 in. (25.4 x 24.1). Inscription (lower right): "The Flying Swings/Prendergast,/July '96." Provenance: Mrs. Charles Prendergast, Westport, Connecticut, Kraushaar Galleries, New York, Mr. and Mrs. William M. Fuller, Marcia Fuller French.

magical world of Charles' imagination, in the spirit of Paul Gauguin and Henri Matisse's admiration of the exotic and achievement of highly decorative, personally symbolic works. American collectors (Lillie P. Bliss, John Quinn, and Albert C. Barnes) who admired these French artists patronized Charles Prendergast as well.

This decorative appeal of color, reflection, and insistent pattern is shared by Charles' brother, Maurice Prendergast. The two worked closely together, with Maurice's involvement in imaginary, abstract painting following a period of relatively illustrative work. This early period of Prendergast's career can be seen in three Fuller pictures, painted during his first important European sojourn of 1891-1895. While in Paris, he studied at the Académie Julian, but took the greater opportunity of observing Impressionist and Post-Impressionist paintings. Important to him as well was the experience of Parisian life and the related atmosphere of coastal resorts visited in the summer. Such appreciation of contemporary life and identification of scene bring Prendergast's early work into the realm of both the American Impressionists and the Philadelphia artist-reporters. But these interests yielded far different results for Maurice Prendergast. The impact

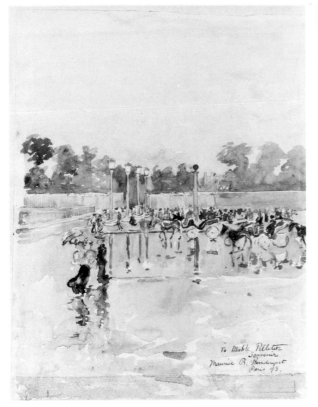

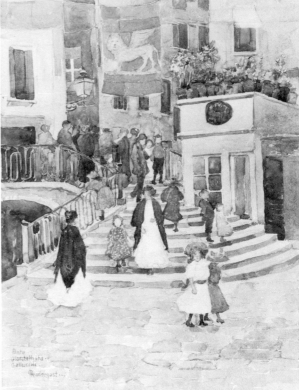

41. Maurice Brazil Prendergast, *Paris Boulevard in the Rain*. 1893. Pencil and watercolor on paper, 13 x 10 in. (33.0 x 25.4). Inscription (lower right): "To Mable Pelletier/Souvenir/Maurice B. Prendergast/Paris 93." Provenance: Mable Pelletier, M. Knoedler & Co., Inc., New York, Mr. and Mrs. William M. Fuller, Marcia Fuller French.

42. Maurice Brazil Prendergast, *Ponte Gianbattista Gallucioli*. 1898. Pencil and watercolor on paper, 15 x 11 in. (38.1 x 27.9). Inscriptions (lower right): "Prendergast," (lower left): "Ponte/Giamtattista [*sic*] Gallucioli/Prendergast" Provenance: Mrs. Montgomery Sears, Boston, Massachusetts, Mrs. J. D. Cameron Bradley, Boston, Massachusetts, M. Knoedler & Co., Inc., New York, Mr. and Mrs. William M. Fuller, Adelaide Fuller Biggs.

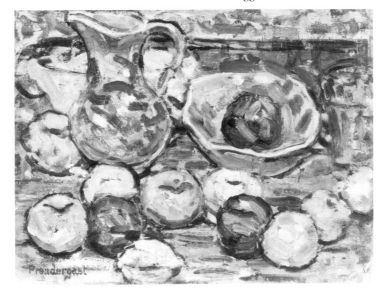

43. Maurice Brazil Prendergast, *Still Life with Blue Pitcher*. 1912. Oil on wood panel, 10-3/8 x 13-3/4 in. (26.3 x 34.9). Inscription (lower left): "Prendergast." Provenance: Mrs. Charles Prendergast, Westport, Connecticut, Mr. and Mrs. William M. Fuller.

of Whistler's work was one reason. He came to know Whistler's paintings and to paint in oils about 1891. James Morrice, a Canadian artist working in Paris, introduced his fellow student to the use of oils on small wood panels, or *pochades*, and Prendergast began to paint out-of-doors. One of his first panels, *Dinard, View of St. Malo* (figure 35), is inscribed with the date of 1891 and the location of Dinard, along the Normandy coast. Despite such specificity the small picture seems timeless, and exhibits a great concern for internal design. Regard for reproducing the effects of atmosphere and weather to suggest mood is akin to Whistler's *crépuscules* of the 1860s, to which *Dinard* bears a striking resemblance.

During the 1890s watercolor was the medium most often chosen by Prendergast. It was a perfect choice for with it he achieved a luminosity and delicacy rarely approached in American painting. The city on a rainy day in *Paris Boulevard in the Rain* (figure 41) or the seashore in full summer in *Fishing Boats, Normandy* (figure 38) and *Along the Shore — St. Malo* (figure 31) display an early mastery of the medium. His touch is distinctive, and his feeling for form prophetic of the more purely formal and aesthetic concerns of the years following his return from Venice.

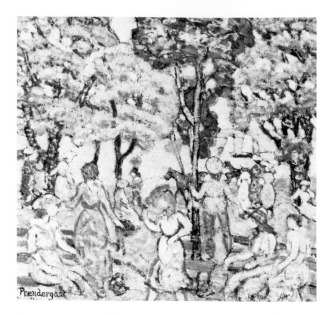

44. Maurice Brazil Prendergast, *Summer Day in the Park*. Oil on canvas, 25-3/4 x 26-3/4 in. (65.4 x 68.0). Inscription (lower left): "Prendergast." Provenance: Mrs. Charles Prendergast, Westport, Connecticut, Kraushaar Galleries, New York, Mr. and Mrs. William M. Fuller.

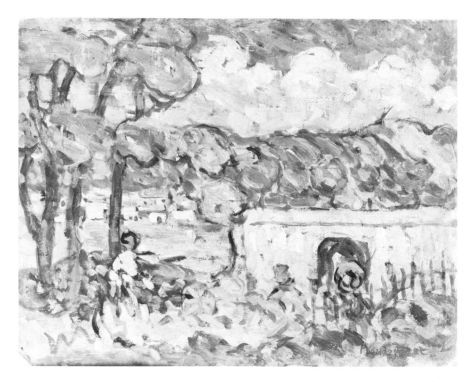

45. Maurice Brazil Prendergast, *Windy Day*. Oil on illustration board, 10-1/2 x 13-3/4 in. (26.6 x 34.9). Inscription (lower right): "Prendergast." Provenance: Mrs. Charles Prendergast, Westport, Connecticut, Kraushaar Galleries, New York, Mr. and Mrs. William M. Fuller, Marcia Fuller French.

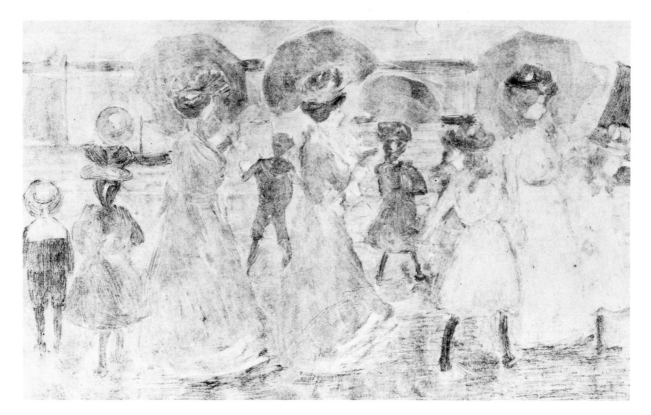

46. Maurice Brazil Prendergast, *Afternoon Prom-enade*. 1900. Monotype, Sheet: 11 x 15-5/8 in. (27.9 x 39.7); Image: 7-1/2 x 11-3/4 in. (19.1 x 29.8). Inscription (lower left): "MBP" [monogram]. Provenance: Mrs. Charles Prendergast, Westport, Connecticut, Kraushaar Galleries, New York, Mr. and Mrs. William M. Fuller, Marcia Fuller French.

The first trip to Venice, on which he was joined by Charles, took place in 1898-1899. The city provided a pageantry and color greater than Paris, and Prendergast immersed himself in its contemporary splendor and traditional Renaissance art. Some of his finest watercolors are of Venice, including *Ponte Gianbattista Gallucioli* (figure 42), which originally belonged to his early, influential patron, Mrs. Montgomery Sears. Here the color and mood of Venetian heraldic flags, flower stands, and fine architecture are joyously conveyed. With the Venetian watercolors and amusement park scenes of the previous years, Prendergast begins to develop an attitude toward form and color that will become the language of his mature work. He discovered distinctive forms to represent Venetian street crowds, each element fitting into a dominant pattern of curving lines and rounded shapes.

Paris and Venice did not offer the only urban inspiration for Prendergast during these years. His home in Boston and the surrounding beaches afforded similarly fine subjects for his brush during the 1890s. *The Flying Swings* (figure 40) is one of a series of children at play on the shores near Boston. Boston, too, was the setting for the only prints Prendergast made — monotypes in the Whistlerian mode. Unlike the bright color of sunlit days on Revere Beach, low-keyed tonal variations of cloudy days and early evenings are themes of the monotypes (figures 46, 47, 48, and 49). The subjects are Whistler's — harbor and city views and figures of women — and the technique that favored by Degas, whose monotypes Prendergast may have known. This medium, in which each impression is unique, and only slightly changed with successive repaintings of the plate, enabled Prendergast to achieve effects of

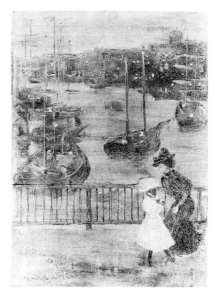

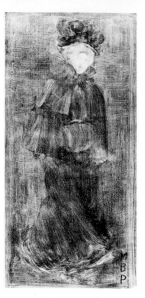

47. Maurice Brazil Prendergast, *Esplanade, Boston*. Monotype, Sheet: 14-5/8 x 10-1/2 in. (37.2 x 26.7); Image: 10-1/8 x 7-1/8 in. (25.7 x 18.1). Inscription (lower left): "Prendergast." Provenance: Mr. Lawrence Fleischman, Kraushaar Galleries, New York, Mr. and Mrs. William M. Fuller, Marcia Fuller French.

48. Maurice Brazil Prendergast, *Lady with Feathered Hat*. 1897. Monotype, Sheet: 13-1/8 x 8-3/8 in. (33.3 x 21.3); Image: 9-1/4 x 4-1/2 in. (23.5 x 11.4). Inscription (lower right): "M/B/P." Provenance: Mrs. Charles Prendergast, Westport, Connecticut, Kraushaar Galleries, New York, Mr. and Mrs. William M. Fuller, Adelaide Fuller Biggs.

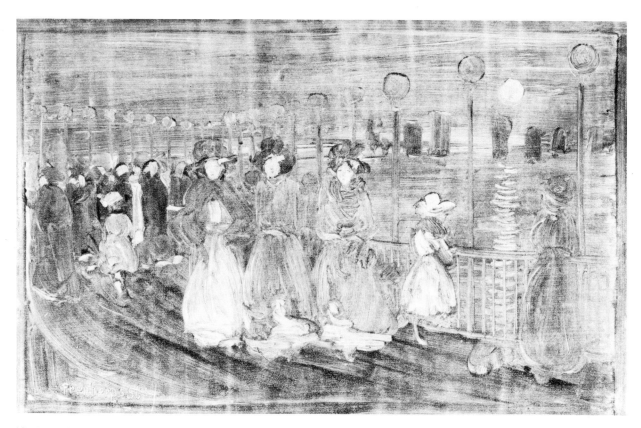

49. Maurice Brazil Prendergast, *On the Pier*. Monotype, Sheet: 11 x 15-1/2 in. (27.9 x 39.4); Image: 8-1/8 x 13-3/4 in. (20.7 x 34.9). Inscription (lower left): "Prendergast." Provenance: Mr. Sidney Cohn, New York, Kraushaar Galleries, New York, Mr. and Mrs. William M. Fuller, Adelaide Fuller Biggs.

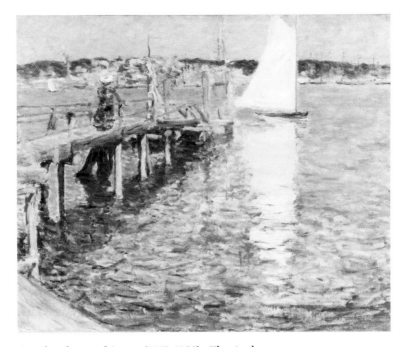

50. Theodore Robinson (1852-1896), *The Anchorage, Cos Cob, Connecticut*. 1894. Oil on canvas, 20-1/8 x 24-1/8 in. (51.1 x 61.3). Inscription (lower right): "Th. Robinson." Provenance: Estate of the artist, William T. West [?], George Low, Charles Wisner, James Graham & Sons Galleries, New York, Mr. and Mrs. William M. Fuller.

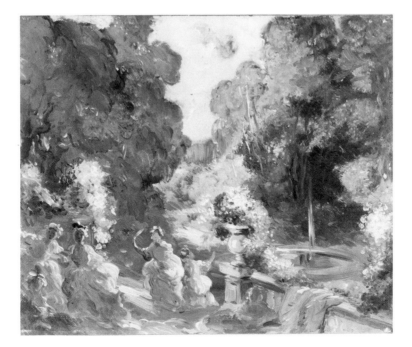

51. Everett Shinn (1876-1953), *Design for Theater*. Before 1910. Oil on canvas, 10-1/8 x 12 in. (25.7 x 30.5). Provenance: Estate of the artist, Davis Galleries, New York, Mr. and Mrs. William M. Fuller, Marcia Fuller French.

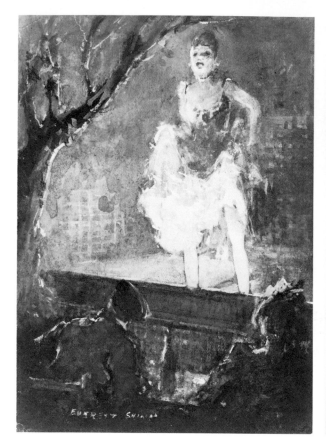

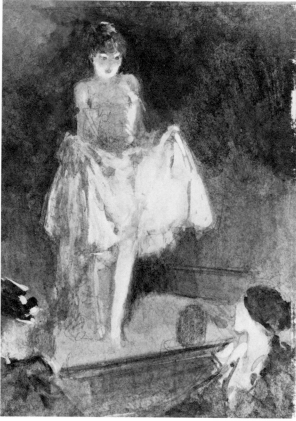

52. Everett Shinn, *Paris Cabaret Singers — Theater Girl in White*. c. 1917. Pencil, watercolor, gouache, and pastel on paper, 6 x 4-1/4 in. (15.2 x 10.8). Inscription (lower left): "Everett Shinn." Frame by Stanford White. Provenance: Estate of the artist, James Graham & Sons Galleries, New York, Mr. and Mrs. William M. Fuller, Marcia Fuller French.

53. Everett Shinn, *Paris Cabaret Singers — Theater Girl in White*. c. 1917. Pencil, watercolor, gouache, and pastel on illustration board, 6-1/8 x 4-1/4 in. (15.6 x 10.8). Frame by Stanford White. Provenance: Estate of the artist, James Graham & Sons Galleries, New York, Mr. and Mrs. William M. Fuller, Marcia Fuller French.

great subtlety and varied tonal balances as he worked through a limited number of themes. Throughout the series the specific location of Boston begins to be less important than experimentation with variations of tonal effects and compositions.

The monotypes, two hundred of which were printed between 1892 and 1905, were means for Prendergast's transition to a new mode of painting. Although he continued to work in watercolor, oil became his preferred medium after 1905. Subjects are ostensibly the same — scenes of leisure on beaches and in city parks — but the definite time and place of the watercolors give way to a more universal language of form and color. In part, this may be due to the artist's almost complete loss of hearing about 1905 and subsequent entrance into a visual world bounded by canvas and pigment. More important was the fulfillment of his experience with European

modern painting and coming into artistic maturity.

Still lifes and portraits, such as *Flowers in a Bowl* (figure 39), *Still Life with Blue Pitcher* (figure 43), and *Boy with Red Cap* (figure 34), become more prominent in his *oeuvre* and indicate an increased awareness of Paul Cézanne's still lifes and portraits which he saw in the Parisian memorial exhibitions of 1907. *Still Life with Blue Pitcher* (figure 43), in particular, is strongly reminiscent of Cézanne's formal concerns translated into Prendergast's unique fluidity of decorative design. The paintings of Wassily Kandinsky, exhibited at the Armory Show in 1913, must have affected Prendergast as well, as evident in the imaginary, almost spiritual evocation of landscape in *Edge of the Grove* (figure 37). Titles of Prendergast's paintings of the teens are repetitive and generalized; figures by the shore or in a city park called "Bathers" or "Promenades" abound. The

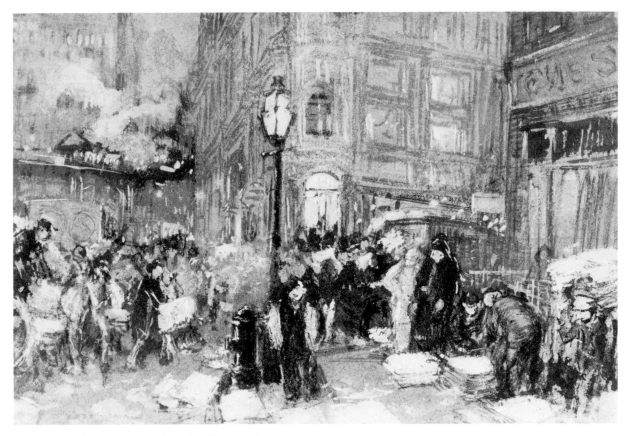

54. Everett Shinn, *Park Row, Morning Papers*. Pencil, charcoal, watercolor, and gouache on paper, 8-1/2 x 13 in. (21.6 x 33.0). Inscription (lower left): "Everett Shinn." Provenance: Estate of the artist, James Graham & Sons Galleries, New York, Mr. and Mrs. William M. Fuller, Marcia Fuller French.

specific location of Paris, Venice, or Boston and a definite time of day have been given up for universal themes of urban and seaside leisure. Prendergast reached the apex of a remarkably productive career in the large, late canvases like *Summer Day in the Park* (figure 44) and *Bathers in a Cove* (figure 32). The themes are viable and moving yet are overridden in importance by the extraordinary sense of a language of purely formal and coloristic symbols. The best of American painting of the late nineteenth and early twentieth centuries and new considerations of modern European painting are compatible in these, Prendergast's late achievement.

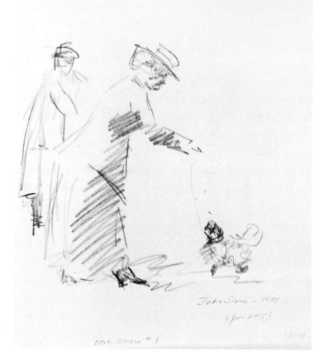

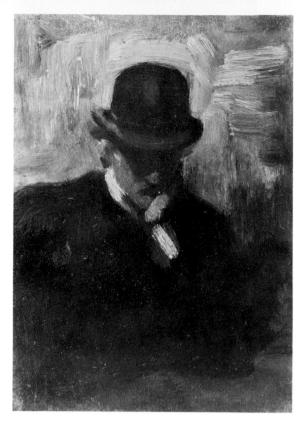

55. John Sloan (1871-1951), *Dog Show #1*. 1907. Pencil on paper, 5-7/8 x 4-7/8 in. (14.9 x 12.4). Inscriptions (lower right): "John Sloan-1907/(per HFS)"; (lower left): "JS #1535"; (lower center): "Dog Show #1." Provenance: Estate of the artist, Kraushaar Galleries, New York, Mr. and Mrs. William M. Fuller.

56. John Sloan, *Portrait of James Preston*. 1897. Oil on wood panel, 6-1/8 x 4-3/4 in. (15.6 x 11.1). Provenance: Estate of the artist, Kraushaar Galleries, New York, Mr. and Mrs. William M. Fuller, Adelaide Fuller Biggs.

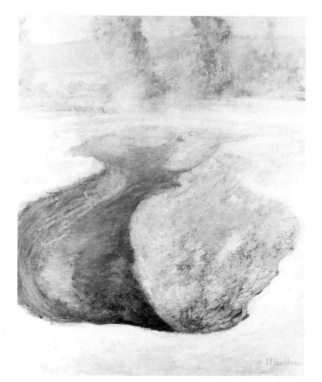

57. John H. Twachtman (1853-1902), *Geyser Pool, Yellowstone*. c. 1890-1893. Oil on canvas, 30 x 24-7/8 in. (76.2 x 63.2). Inscription (lower right): "JH Twachtman." Provenance: Major W. A. Wadsworth, Buffalo, New York, The Milch Galleries, New York, Mr. and Mrs. William M. Fuller, Marcia Fuller French.

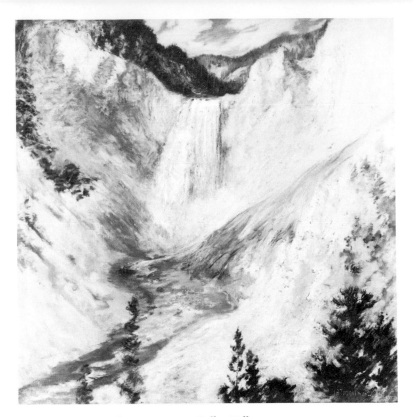

58. John H. Twachtman, *Lower Falls, Yellowstone*. c. 1890-1893. Oil on canvas, 30-1/8 x 30-1/8 in. (76.5 x 76.5). Inscription (lower right): "J.H. Twachtman —." Provenance: Hugo Reisinger, New York, M. Knoedler & Co., Inc., New York, City Art Museum, St. Louis, Missouri, Vose Galleries of Boston, Inc., Boston, Massachusetts, E. C. Shaw, Akron, Ohio, William Macbeth, New York, Addison Gallery of American Art, Phillips Academy, Andover, Massachusetts, Mrs. Francis M. Weld, New York, The Denver Art Museum, The Milch Galleries, New York, The Fuller Foundation.

SELECTED BIBLIOGRAPHY

Bibliographies in the following books and exhibition catalogues will provide further references, particularly to early twentieth-century publications.

Adams, Adeline. *Childe Hassam*. New York, 1938.

Annandale-on-Hudson, New York, William Cooper Procter Art Center, Bard College. *Maurice Prendergast, The Monotypes*. 1967.

Baltimore, The Baltimore Museum of Art. *Theodore Robinson, 1852-1896*. Introduction and commentary by Sona Johnston. 1973.

Berry-Hill, Henry, and Sidney Berry-Hill. *Ernest Lawson, American Impressionist, 1873-1939*. Leigh-on-Sea, England, 1968.

Boston, Museum of Fine Arts. *The Art of Charles Prendergast*, by Richard J. Wattenmaker. 1968.

———. *Maurice Prendergast 1859-1924*. Essay by Hedley Howell Rhys; catalogue by Peter A. Wick. 1960.

Boyle, Richard J. *American Impressionism*. New York, 1974.

Brooklyn, New York, The Brooklyn Museum. *The Eight*. Foreword by John I. H. Baur; essay by Everett Shinn. 1943.

———. *Theodore Robinson 1852-1896*, by John I. H. Baur. 1946.

Brown, Milton W. *American Painting from the Armory Show to the Depression*. Princeton, New Jersey, 1955.

———. *The Story of the Armory Show*. Greenwich, Connecticut, 1963.

Cincinnati, Ohio, The Cincinnati Art Museum. *A Retrospective Exhibition, John Henry Twachtman*. Essay by Richard J. Boyle. 1966.

Clark, Carol. "An American Impressionist's Vision of New York: Childe Hassam's *Union Square in Spring*, Smith College Museum of Art." Unpublished paper, 1972.

College Park, Maryland, University of Maryland Art Gallery. *Maurice Prendergast*, by Eleanor Green, Ellen Glavin, and Jeffery R. Hayes. 1976.

Coral Gables, Florida, Lowe Art Museum, University of Miami. *French Impressionists Influence American Artists*. 1971.

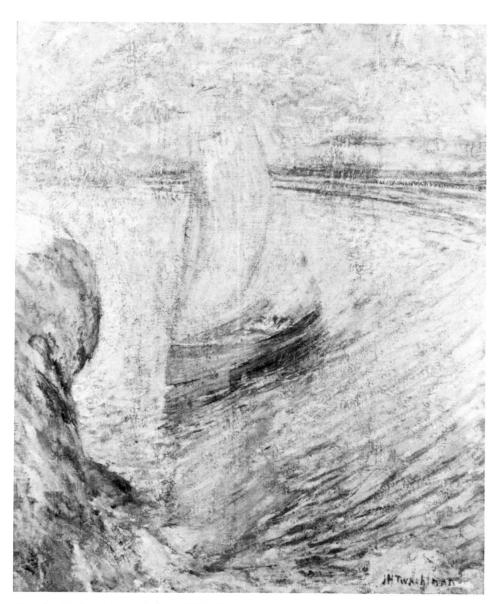

59. John H. Twachtman, *Sailing*. 1892. Oil on canvas, 30-1/8 x 25-1/8 in. (76.5 x 63.8). Inscription (lower right): "JH Twachtman —." Provenance: Mrs. J. H. Twachtman, Greenwich, Connecticut, The Milch Galleries, New York, Mr. and Mrs. William M. Fuller, Marcia Fuller French.

DeShazo, Edith. *Everett Shinn 1876-1953, A Figure in His Time*. New York, 1974.

Glackens, Ira. *William Glackens and the Ashcan Group, The Emergence of Realism in American Art*. New York, 1957.

Hale, John Douglass. "The Life and Creative Development of John H. Twachtman." Unpublished Ph.D. dissertation, The Ohio State University, 1957.

Henri, Robert. *The Art Spirit*. Philadelphia, 1930.

Homer, William Innes. *Robert Henri and His Circle*. Ithaca, New York, 1969.

Hoopes, Donelson F. *The American Impressionists*. New York, 1972.

New Orleans, New Orleans Museum of Art. *A Panorama of American Painting, The John J. McDonough Collection*. Catalogue by E. John Bullard. 1975.

New York, Davis & Long Co. *Charles Conder, Robert Henri, James Morrice, Maurice Prendergast, The Formative Years, Paris 1890s*. Essay by Cecily Langdale. 1975.

New York, M. Knoedler & Co. *Arthur B. Davies, A Chronological Retrospective*. Essay by Joseph S. Czestochowski. 1975.

———. *Paintings and Water Colors by Maurice Prendergast*, by Charles H. Sawyer. 1966.

New York, The Metropolitan Museum of Art. *American Impressionist and Realist Paintings and Drawings from The Collection of Mr. & Mrs. Raymond J. Horowitz*. Introduction by John K. Howat and Dianne H. Pilgrim; catalogue by Dianne H. Pilgrim. 1973.

New York, Whitney Museum of American Art. *John Sloan*, by Lloyd Goodrich. 1952.

Ottawa, The National Gallery of Canada. *Ernest Lawson, 1873-1939*. Essay by Barbara O'Neal. 1967.

Perlman, Bennard B. *The Immortal Eight, American Painting from Eakins to the Armory Show (1870-1913)*. New York, 1962.

Philadelphia, The Pennsylvania Academy of the Fine Arts. *In This Academy, The Pennsylvania Academy of the Fine Arts, 1805-1976*. 1976.

Philadelphia, Philadelphia Museum of Art. *From Realism to Symbolism, Whistler and His World*. Essays by Allen Staley and Theodore Reff. 1971.

Pierce, Patricia Jobe. *The Ten*. Concord, New Hampshire, 1976.

St. John, Bruce, editor. *John Sloan's New York Scene, from the diaries, notes and correspondence 1906-1913*. New York, 1965.

San Francisco, M. H. de Young Memorial Museum and the California Palace of the Legion of Honor. *The Color of Mood: American Tonalism 1880-1910*, by Wanda M. Corn. 1972.

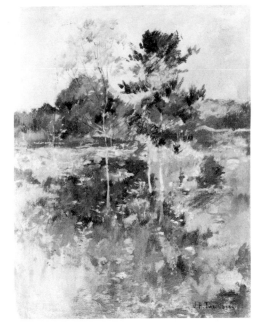

60. John H. Twachtman, *Springtime*. c. 1900-1902. Oil on wood panel, 18-1/8 x 13-3/4 in. (46.3 x 34.9). Inscription (lower right): "J.H. Twachtman —." Provenance: Julia Peck, Richard Andrae, Du Mouchelle Art Galleries, Co., Detroit, Michigan, Kraushaar Galleries, New York, James Graham & Sons Galleries, New York, Mr. and Mrs. William M. Fuller.

Scott, David. *John Sloan*. New York, 1975.

Trenton, New Jersey State Museum. *Everett Shinn 1873-1953*, by Edith DeShazo. 1973.

Tucson, Arizona, University of Arizona Museum of Art. *Childe Hassam, 1859-1935*. Essay by William Steadman. 1972.

Utica, New York, Munson-Williams-Proctor Institute. *Arthur B. Davies (1862-1928), A Centennial Exhibition*. 1962.

———. *George Luks 1866-1933, an exhibition of paintings and drawings dating from 1889 to 1931*, by Ira Glackens and Joseph S. Trovato. 1973.

Washington, D.C., The Corcoran Gallery of Art. *Childe Hassam: A Retrospective Exhibition*. Essay by Charles E. Buckley. 1965.

Washington, D.C., National Collection of Fine Arts. *Drawings by William Glackens 1870-1938*. Essay by Janet A. Flint. 1972.

Washington, D.C., National Gallery of Art. *American Impressionist Painting*, by Moussa M. Domit. 1973.

———. *John Sloan, 1871-1951*. Essays by David W. Scott and E. John Bullard. 1971.

Young, Mahonri Sharp. *The Eight, The Realist Revolt in American Painting*. New York, 1973.

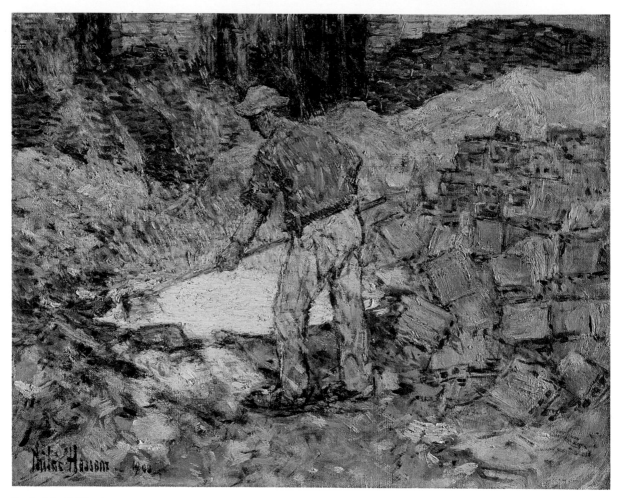

Frederick Childe Hassam
The Laborer (figure 10)